PAINTING WITHOUT A BRUSH

David Ferry

PAINTING WITHOUT A BRUSH

David Ferry

THE WELLFLEET PRESS
WELLFLEET

A QUARTO BOOK

Published by Wellfleet Press
110 Enterprise Avenue
Secaucus, New Jersey 07094

ISBN 1-55521-719-2

This book was designed and produced by
Quarto Publishing plc
The Old Brewery, 6 Blundell Street
London N7 9BH

Publishing Director Janet Slingsby
Art Director Moira Clinch
Assistant Art Director Chloë Alexander
Picture Researcher Jane Lambert
Senior Editor Hazel Harrison
Designer Giles Davies
Photographers Paul Forrester, Martin Norris, Robert Tegg
Special thanks to John Grain

Typeset by
En to En, Tunbridge Wells
Manufactured in Singapore by
Chroma Graphics (Overseas) Pte. Ltd.
Printed in Hong Kong by Lee-Fung Asco Printers Limited

CONTENTS

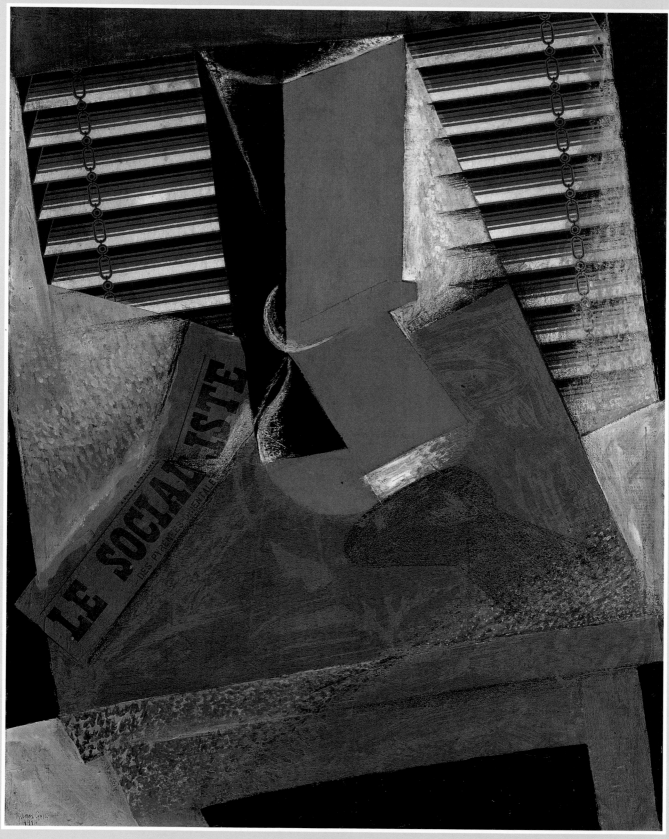

The Sunblind
Juan Gris
1914

Introduction

Dream
Julian Trevelyan
1939

Creative artists have always pushed their materials to the limits in the quest to produce something personal.

The aim of this book is to encourage the reader to break away from the conventional approach to painting and drawing and explore "alternative" methods of picturemaking. This can be a liberating experience, not only for the amateur who is discouraged by lack of technical skill, but also for the professional artist who has become over-dependent on one particular medium or technique.

In our technological age, new methods of image-making are constantly presenting themselves; the camera, the photocopier and the colour printer can all be used as extensions of the artist's palette. Many of the projects that form the core of the book make use of materials that seem to have little to do with art, but as you will see, the end-products have everything to do with it. The methods used vary enormously, adding a creative and exploratory dimension to the picturemaking process that is not always present in more conventional approaches.

Many of these projects, especially commissioned and generated for the book, cannot be categorized in purely technical terms. That is, they cannot be grouped together as watercolours, oil paintings, pastels or prints, as pictures frequently are in exhibition catalogues. Most are a mixture springing from the inspiration and ingenuity of each artist, and if they were on exhibition they would be described as mixed media. This is usually an unhelpful term as most viewers have no real idea of how each part of the picture was actually made. The book, however, will make this very clear: we shall follow the artists through every step of the making of works that, although they may use "offbeat" materials and techniques, are no less rich and meaningful than any picture made strictly by traditional methods.

Naturally the styles of the artists vary considerably, as do their interests and pictorial preoccupations, but the common factor which links them all is a high degree of awareness of their materials and how they use them. Throughout the book we will see how artists "process" their subjects and mould them into their own specific handwriting. The emphasis in all cases is on the interaction between artist, subject matter and materials.

In order to help the reader to understand and appreciate specific differences in materials and technique, the book has been divided into three main categories: drawing and painting, collage and simple printmaking. However, no one section or technique is seen in isolation. There is a constant cross-fertilization between each section: painting and drawing methods explained in the early chapters reappear in the later ones used in conjunction with collage and printmaking, while the photographic image, utilized in the first chapter as part of the artist's "reference store", comes into its own as subject matter for photocopied collage.

Thus the book works on two levels. It can be dipped into for occasional inspiration on specific ideas and methods or it can be read as a whole volume. In the latter case you will participate in the artist's cycle of creative activity, from the first conception of an idea to its full realization. Art is as much about doing as it is about looking, and the special relationship between chosen subject and materials is the perfect blend of the two.

GETTING STARTED

The "doing" aspect can have a liberating effect, because once engaged in the physical process, the imagination begins to reinterpret the way we perceive things, or even to invent things that are not strictly speaking perceived. But how are

these activities – both mental and physical – generated in the first place? How do artists get started? It is not enough just to think something will make a good subject; any idea needs a structurally sound "platform" on which to rest if it is to be taken further. The building of this imaginary platform is a vital step in the act of perception, and the collecting, sifting and general sorting out of visual material are the bricks in the building process.

The first project in the book concerns just this information-gathering process. Obviously this cannot and should not offer a prescription for all circumstances, but it does provide some thought-provoking ideas on how one particular artist begins the process of building from subject matter to completed image, using sketches and photographs to collect a store of information. The projects that follow this "first base" become increasingly challenging to take into account the reader's growing confidence and willingness to experiment constructively.

Pictorial ideas can stem from anything that elicits a visual response on the part of the viewer, real or invented. The next part of the equation, or building process, is to decide how the chosen subject can be conveyed physically, that is, what materials and methods will best express the essence of the idea.

HANDS ON

The question of materials is obviously a central one to this book, and is highlighted in each of the projects. However, this does not mean that any great technical expertise or knowledge is needed, indeed at no time will such issues overshadow the enjoyment of making pictures. Even the projects that make use of what seems to be sophisticated technology, such as the photocopying machine, the camera and the silkscreen, do so only to further the artist's ends. We do not need to know how the photocopying machine works; our only concern is its creative potentialities.

It is also easy to be persuaded, particularly

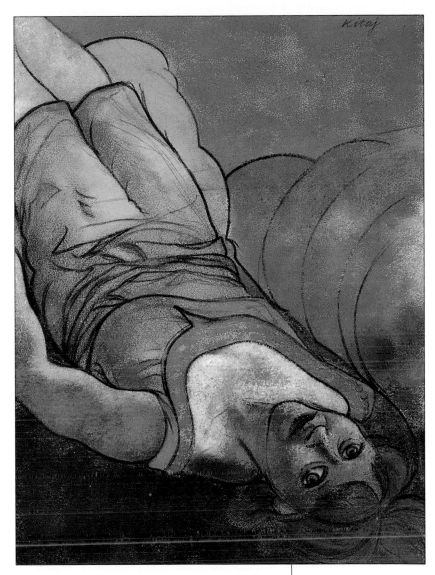

The Green Dress
R B Kitai 1980

Kitai has used traditional drawing materials – charcoal and pastel – for this wonderfully sensuous composition.

when dealing with the world of "conventional" painting, that the most expensive materials are the best. This is a myth that will be quickly dispelled here. Many of the artists have made exciting and creative use of such items as old packaging materials and other salvaged and reprocessed goods rather than paints and paper bought from artist's suppliers and used as per the manufacturer's instructions.

This is nothing new: creative artists have always pushed their materials to their limits in the quest to produce something personal, and this book takes the same approach. Materials and methods are seen not as ends in themselves but as starting points for further pictorial investigation. You may encounter some materials that you have not hitherto connected with art, but as you will discover, it only takes invention and a

*The camera can be used in conjunction with the sketchbook
as the first stage in producing a picture.*

receptive mind to blend the commonplace into a workable and responsive art material.

This kind of experimentation should be seen as a natural consequence of the desire to create pictures. The world is in a constant state of development and flux, and as new images present themselves to the artist, he or she will naturally look for new ways to explore and express them. Creativity must renew itself; an artist who discovers and masters one technique or process and continues to use it, secure in the knowledge that it once worked, runs the risk of relegation to the role of technician.

Although most of the finished images in the book were made in studios or at least indoors, none is reliant on a professional studio situation, elaborate equipment or any prior expert knowledge. They also have in common two other qualities, low cost and accessibility, that is, they

can all be done "on the kitchen table". Even the printmaking section is of a fundamental nature – no press is needed, and only the most basic of equipment.

AN EXTENDED ARTIST'S PALETTE

To return to cost, we are in a fortunate position today, as the expensive and sophisticated technology that produces our daily reading matter has given us a marvellous, inexpensive visual "spin-off" of pictorial possibilities, an intriguing anomaly in a society geared to mass production and productivity targets. Recycled materials, as we have seen, can be used effectively in collage, while both text and pictures in newspapers can be reassembled in the context of creative picturemaking. These things, which you can say cost you nothing because you bought them for another purpose in the first place, can make as exciting a piece of art as costly oil paints on equally costly canvas.

This is only one way in which technology can benefit the artist. Two more exciting and direct ones are the development of the fast photographic printing machine and the photocopier, both of which are now available in most towns. It is now possible to have a roll of film developed and printed in a matter of minutes.

Photographs, which need be nothing more ambitious than family snapshots, can be used just as they are as the basis of a collage, or they can be placed on a photocopier and enlarged, reduced, edited and manipulated in a number of ways to produce fascinating images and textures. To the uninitiated this may sound like cheating, but if you need reassurance that technology can go hand in hand with creativity, turn to the collage chapters.

One major contemporary artist who has made

Venice
Jiri Kolar 1968

Two extremely simple procedures were employed to make this impressive photographic collage. Collaged newspaper texts were used as a "backcloth", and a photographic reproduction was guillotined into strips, reassembled and then glued down on top of it. The artist has thus produced a visual play on the accepted way of reading images.

Gregory Swimming
David Hockney 1982

In his composite Polaroid collages, in which many single photographs are placed together, Hockney is able to produce a vivid and informative reconstruction of actions or places. One single photograph would have made far less visual impact than the 120 used here.

consistent use of the new technology is David Hockney, who has paved the way for its inventive and imaginative application. His striking photographic collages are a remarkable testimony to the artist's successful adaptation of commonplace tools and services. A particularly impressive aspect of his collages is the use of standard-size photographic prints, which he places side by side, joins or overlaps to produce a richly enhanced reading of the original subject matter.

Using photographs as the basis for art is another example of the recycling process mentioned earlier. The camera and the sketchbook both play an important role in the initial research and collecting of information for a picture, but it need not end there. Using the "high street" technology allows you to use these examples of research as works in their own right to make a different visual statement about the same subject.

An Individual Approach

It is important to remember, however, that although we may use the new technology we must never become bound by it. Both photographs and photocopies can be vital in helping the artist to recapture an impression or feeling about a place, person or object, but neither provide a short cut or an easy form of image-making. Each individual will use them differently, just as no two people will use colour in exactly the same way.

The projects that follow are not intended as recipes but as a stimulus to help you develop your own ideas, methods and personal vision of the world. They should inspire the spirit of individual experiment and enquiry that is the hallmark of the true artist. The work of other artists can act as a rough map to guide you through the country of creative image-making, but ultimately everyone has to find their own route. I hope that the book will help you to do this.

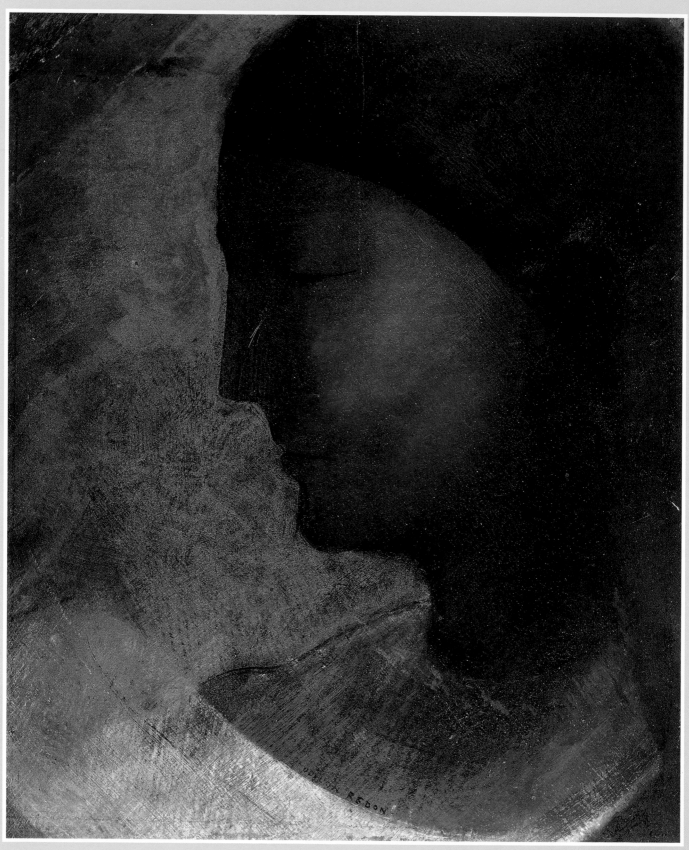

The Golden Honeycomb
Odilon Redon
1894

Chapter

1

DRAWING MATERIALS

The Origin of the Clock
Max Ernst
1926

Previous pages (left) Redon's remarkable picture, made with oil paint, gold pigment and pastels, demonstrates the visual dynamism of simple shapes and intense colours.

Previous pages (right) Max Ernst's drawing is one from a series of thirty-four frottages entitled *Histoire Naturelle*. Frottage, a simple technique of placing drawing paper over a texture and then rubbing through with a soft pencil, is traditionally associated with brass-rubbing.

Head of Ken Garland
Frank Auerbach 1977/8

This powerful drawing (below) is a good example of the rich and varied marks that can be made with charcoal, one of the most popular and versatile of all drawing materials.

In our technological age, new methods of image-making are constantly presenting themselves.

t is important to stress before embarking on the main part of the book that a large number of the projects in later chapters are studio-based, that is, they have taken off from an initial idea rather than being carried to completion in front of the subject. This is not intended in any way to devalue location work, which must always play a vital part in the preliminary stages of a picture, but the emphasis throughout the book is on pushing an idea further and developing it not just in one way but in several. In order to stress this aspect of picturemaking, I have shown several different versions, or interpretations, of what is basically the same subject matter.

This chapter concentrates on two things – the initial gathering of material and the simultaneous or later exploitation of it through traditional "dry" materials – pencils, charcoal and pastels, used in such a way that they transcend their purely physical characteristics to become personal to each artist. Because we are concerned with beginnings here, the artists

featured in the projects are, with one exception, working on location directly from outdoor subjects.

VISUAL RESEARCH
The choice of subject matter itself can present a bewildering myriad of choices for the artist, but once it is decided on, whether it is a building, a landscape, a group of people or a still life, the next step is to research it thoroughly so that when you come to make the picture or pictures you have all the information you need.

Purists have often criticized the use of the camera as an aid to drawing and observing, seeing it as a lazy way out, but such an attitude has no place in this book. The camera is seen throughout as a vital addition to the artist's palette. Not only are photographs used in combination with the sketchbook as means of amassing visual data, they also reappear in later chapters as part of the raw material of collage.

However, if you are to make a comprehensive record of the subject, which must include your

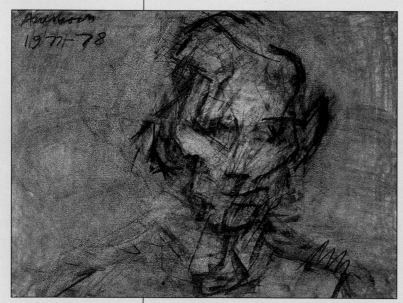

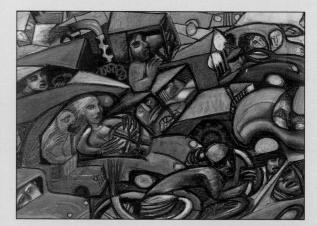

The Traffic Jam
Colin Spratt 1990

The clamour of modern city life is marvellously conveyed (above) by the crowded juxtaposition of shapes and colours. Spratt has used chalk pastel built up in layers to produce rich colours.

personal response to it, photographs are only a beginning, as the camera cannot replace the spontaneity of hand and eye. Here is where the sketchbook comes in, because this can act as a personal and direct link between you and what you see.

Moreover, the sketchbook allows you to take the first steps towards planning the picture, even if only in the form of rapid scribbles and written notes about colour, texture and so on. The more information you can gather in this way the better, as planning the final composition involves a mental editing process, which you will see being carried out in the examples of artists' work.

DRY MATERIALS

In the context of information-gathering, or sketching, the obvious choices of material are those traditionally used for drawing: charcoal, pencils and coloured pencils, fibre-tipped pens and the various kinds of pastels. None of these require complicated mixing or preparation, and all (with the possible exception of soft pastels) are inexpensive and readily available. Their use, however, need not be restricted to the initial on-the-spot sketching stage, as all have considerable creative possibilities in the wider context of actual picturemaking.

Nor need they be used in the purely linear manner usually associated with drawing. Charcoal, for instance, gives a marvellous line, but it can also be worked into with white spirit for a more fluid and painterly look. Soft pastels can be used very much like paint: large areas can be covered with the side of the stick, and colour can be spread with water.

Edgar Degas, one of the finest-ever exponents of this medium, used to make his pastels into a kind of paste with hot water so that he could contrast "painted" areas with "drawn" ones. He would probably have enjoyed oil pastels had they been invented at the time, as these, mixed with white spirit, can be used equally successfully as both paints and chalks.

In the projects that follow I have tended to

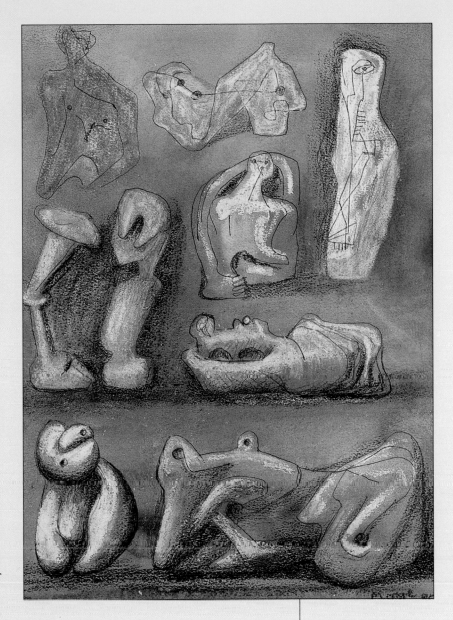

stress the wider application of these materials. This book is not about drawing or painting techniques; it is about "alternative" systems of picturemaking which, when combined, produce exciting (if not technically purist) images.

Ideas for Sculpture
Henry Moore 1980

Moore's drawings also take the form of exploratory research, into both forms and techniques. These visual notes of mental processes were a vital stage in the development of his sculptures as well as being superb works in their own right. The materials used here include a ball-point pen, wax crayons, pastels and watercolour.

PROJECT 1

COLLECTING INFORMATION

David Ferry demonstrates his visual research methods.

This project acts as a lead-in to the following one, and the two are intended to be looked at in sequence. On these pages, I demonstrate how, once I have chosen the subject, I go about amassing the visual material I need, while on the following pages I carry out the visual editing process which is always needed when making pictorial notes into a finished image.

The choice of subject must always be a personal one, as we do not all find fascination in the same things, but it is easier to decide on a subject if you have some idea of what you intend to say about it in pictorial terms. I have chosen a ruined building in this case because it is full of interesting textures and architectural details, and I know that these will provide enough material and stimulus for several different interpretations.

Visual research can come in many shapes and forms, but I have chosen the most immediate of tools and materials – the camera, a notebook and a set of felt-tipped pens, which enable me to break down the subject quickly into basic colour components. I have also used more traditional drawing materials to make notes about specific architectural details and textures. The camera was important, as I used it simultaneously with the sketchbook, thus creating two different first-hand perspectives of the subject.

I have collected a good deal of varying material in order to extend the range of possibilities and have a wide choice of elements available for the larger-scale picture I have planned. Many aspects of the subject can be captured in preliminary studies such as these – colour, perspective, distance, scale, atmosphere and texture. For the latter, I have taken rubbings on tracing paper, a rapid and direct way of recording information about surfaces.

Although I have initially carried out this research for a specific picture, the material will not be restricted to this alone. Throughout the book I shall stress the concept of "recycling", that is, using the information gathered for one piece of work in several different ways and in conjunction with other methods. This allows a richer and fuller creative approach in which the subject is expressed through a variety of pictorial languages.

Materials & Equipment

Sketchbook

Camera and colour print film

Coloured pencils

Oil pastels

Markers

Felt pens

Tracing paper

▼ **1** Once I have chosen the subject I begin to amass a variety of pictorial information. This photograph gives a clear although at this stage non-selective view of the location.

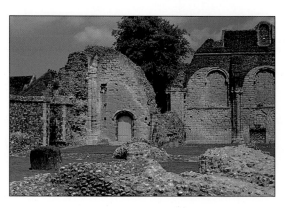

◄ **2** In order to investigate more specific aspects of the scene I use a simple viewing window. This allows me to isolate various interesting details for possible selection.

► **3** One of the most characteristic elements of the place was the texture of the old stone and brickwork. I have made very direct and accurate notes of this by taking "rubbings". Tracing paper was placed on the wall and rubbed over with oil pastel. At a later stage these impressions can be transferred to the working surface by ironing.

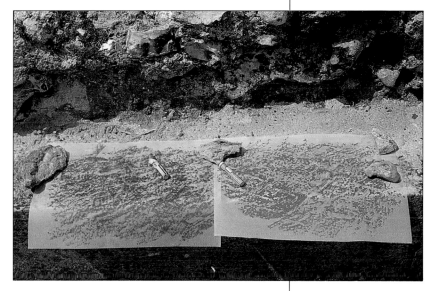

▲ **4** A display of some of the collected information. Notice that I use both photographs and drawings, which will inform many later reworkings of the subject. The combination also provides a wider overview of the location than either a single drawing or a single photograph.

◄ **5** An example from my sketchbook showing aspects of texture, form and colour which will later become a basis for finished images. These studies were made both on and after the visit to the scene.

PROJECT 2

FROTTAGE AND TEXTURE

Having re-assessed his visual notes, David Ferry now uses them as a basis for a finished picture.

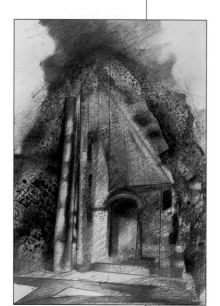

The Single Doorway
106.7×76.2cm
(42×30in)

Materials & Equipment

Pictorial information as shown on pages 16-17

Drawing board, good-quality cartridge paper

Inexpensive paper for masking

Coloured pencils, various grades

Artist's coloured inks

Spray paint

Corrugated cardboard, sandpaper (various grades)

Scissors, penknife

Cotton buds

Domestic clothes iron

Having collected the material as shown on the preceding pages, the next stage was to work out the composition itself. Although I had already decided on the subject matter in general terms, this is not at all the same thing as composing a picture, and my first decision concerned which particular aspect of the ruined building to home in on.

The final choice for this composition was arrived at after I had spread out the photographs and studies in my working area. This allowed both the direct experience of the place and my subsequent re-assessment of it to filter back through my mind so that I could test out my original ideas in the light of the assembled information.

When you are not fully decided on the exact form a picture will take, it is reassuring to have this amount of information to hand. You can then make further experimental sketchbook studies, trying out various different arrangements and formats before committing yourself to paper.

Patience and perseverance are the keynotes here – the planning stage of a picture is not one to rush.

I arrived at my final composition through just such a series of experiments. It was chosen for the simplicity of design and the uncompromising focus on the single doorway surrounded by a network of texture and colour.

It is often necessary to single out a particular detail or feature, especially in the case of a complex subject where there are so many different possibilities. To try to put every angle, texture and detail into one picture would overcrowd it and thus reduce it to a confused mass of indigestible material.

This does not mean that any of my original research will be lost or useless. In order to give a fuller description of the subject, I shall use some of the masks, studies and photographs again for future projects. Choosing one aspect of a subject necessarily means excluding others, but it is usually possible to re-examine the reference material later with a view to making another picture in which some other favourite detail is given prominence.

▶ **1** I begin with a pencil drawing to establish the composition, referring to the outside location studies as I work. It is important to have all this to hand when starting the picture.

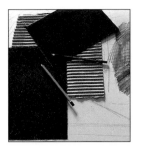

◀ **2** The frottage technique involves placing various textured materials under the drawing paper. In this case I have used sandpaper and corrugated cardboard.

▶ **3** The results of the frottage method can be seen here. As in a brass-rubbing, the texture of the material below the paper is accurately reproduced.

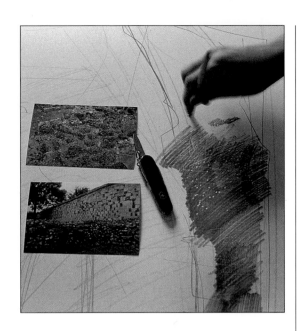

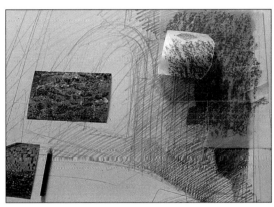

▲ **4** I now intend to transfer the oil pastel frottage from my location visit (see page 17) onto the drawing paper. It is placed pastel side down.

▶ **5** Using a domestic clothes iron (on a low setting), I iron the pastel onto the working surface. This can only be done with oil pastel; a frottage made with ordinary pastel or pencil is not transferable.

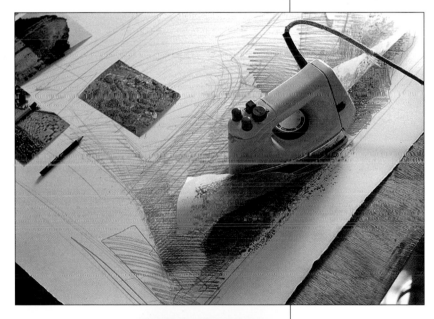

▶ **6** Here you can clearly see the effect of the transferred red pastel texture, which has now become part of the overall composition. The same method can be used to create texture on top of previously drawn or painted areas of a picture.

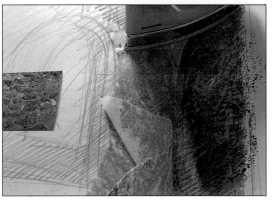

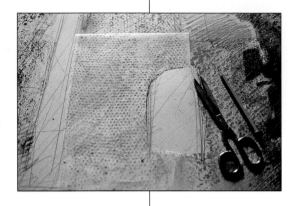

▲ **7** Pieces of frottaged tracing paper can be cut to any shape required, as here.

► **8** This photograph shows both frottage techniques together, the coloured transfer one and the carbon pencil direct rubbing from the corrugated card and sandpaper.

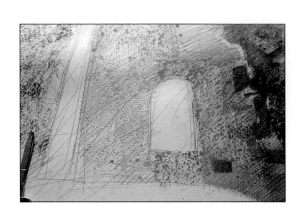

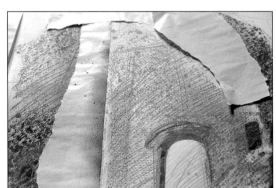

◄ **9** I am now going to apply colour with an aerosol spray, so have made simple paper masks for the areas to remain clear of paint. The torn edges help to maintain the effect of the crumbling stone wall.

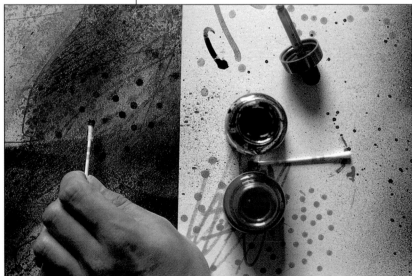

▲ **10** I use artist's inks to add a final touch of colour and texture to the picture. Cotton buds were useful in this case, allowing me to make a variety of dabs and linear marks.

► **11** Finally I score parts of the composition with a penknife. This technique, called sgraffito, reveals areas of the pastel texture which had subsequently become hidden by later layers of ink and paint.

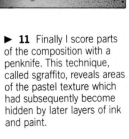

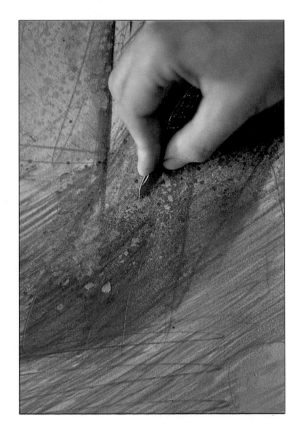

The Single Doorway
David Ferry
106.7×76.2cm (42×30in)

PROJECT 3

CHALK PASTEL

Traditional materials used in an individual and painterly way by Roy Sparkes.

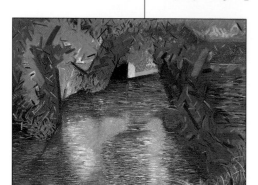

The Moat, Sissinghurst
36.2×51cm
(14¼×20⅛in)

Like the previous project, this one takes an outdoor subject as its theme, but in this case the artist worked on location throughout. Only by experiencing a direct relationship with his chosen subject did he feel able to express his personal response to its character and flavour. His choice of subject is one that embraces two different aspects of landscape – strong shapes and forms that remain basically still, such as tree trunks, and the quality of movement and restless change seen in water, sky and foliage.

Because he had to work very quickly to establish the main structure and tones of the scene, he chose chalk pastels, which are robust, durable and capable of producing extremely sensitive nuances of tone and colour. Pastel sticks are sold already graded into a wide range of colours and tints of each colour, and because there is no pre-mixing process, impressions can be recorded very rapidly.

Colours can be blended with the fingers in much the same way as charcoal, thus providing a combination of linear and painterly qualities ideally suited to conveying qualities of light and movement. The range of the medium can be extended further if a mixture of hard and soft pastels is used, as here. The former are more akin to drawing than painting materials, but the two combine well.

Pastels allow for a certain amount of overworking and build-up of colour and tones, and once the basic composition was established the artist was able to work over it and make subtle changes in colour. As the picture progressed he found that the relationship between the calm tranquillity of the water and the dynamic force of the foliage surrounding the river became the kernel and purpose of the picture, and his creative energies were channelled into the task of expressing this duality.

Materials & Equipment

Drawing board

Ingres paper

Chalk pastels

Cotton wool

Fixative

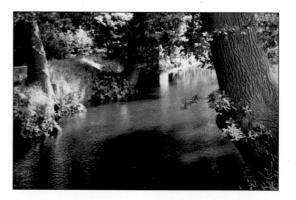

▲ **1** It is interesting to compare this photograph of the actual scene with the artist's treatment of it. The potential for a good composition is there – the trees on either side of the water establish a strong bridging relationship and carry the eye constantly from one side of the composition to the other – but the photograph lacks any drama or vitality.

▶ **2** The initial drawing, in dark pastel, concentrates on the main structure of the composition. No detail is included at this stage, as this will be built up where needed as the work progresses.

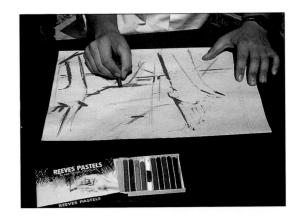

▼ **3** Having established the pictorial structure, the artist lays in large blocks of colour, using a cotton-wool ball to flatten out the pastel and wipe off excess dust.

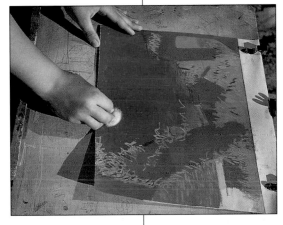

◀ **4** These areas of colour act rather like an underpainting, forming a basis for further working. The artist can now focus on specific detail and texture without destroying the overall design of the picture. When pastel is to be overworked to a large extent it is necessary to fix the first layers of colour so that the later ones do not mix with them.

▼ **6** During the second phase of reworking, a picture began to emerge which seemed to capture the essence of the subject. Some of the initial colours seen in the photograph on the left have now re-emerged, and the main forms have been broken down by the addition of crisp, angular strokes of pure colour.

▶ **5** After extensive reworking the artist has produced a fairly conventional and realistic portrayal of the scene. He is not satisfied with this, and thus decides to rework even further. This involved rubbing away some of the top layer of pastel and then fixing again before adding new colour and drawing.

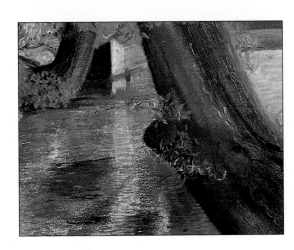

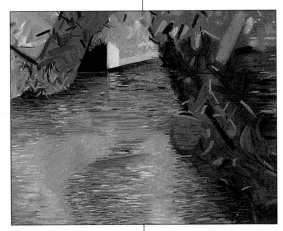

PROJECT 4

OIL PASTEL 1

Roy Sparkes paints with pastels to produce vibrant, glowing colors in this abstract interpretation.

Frindsbury Gardens
54.2×41.3cm
(22½×16¼in)

Materials & Equipment

Drawing board
Watercolour paper
Oil pastels
White spirit
Rags, toothpicks
Craft knife

For this bold abstraction from a landscape subject, the artist has used oil pastel, which even more than ordinary soft pastel crosses the barrier between drawing and painting materials. Oil pastels are really paint in solid form, and although they can be used very much like ordinary pastels they can also be diluted with white spirit, which melts them and turns them into pure paint. This "wash" or mixture can be made on the picture surface itself or on a palette, in which case it is transferred to the picture with brushes, rags, fingers, sponges or cotton buds. Although the pigment cannot be built up as thickly as oil paint, one colour can be laid on top of another, dark over light or vice versa, and as long as the paper used is reasonably tough, mistakes can be rectified by removing areas of colour with a rag soaked in white spirit. A versatile medium which can produce a wide range of effects — fine lines, rich textures and vibrant areas of solid colour.

One technique particularly associated with oil pastel is sgraffito, which involves scratching or scraping through one layer of colour to reveal another one below, which can also be oil pastel but could be a different medium altogether. Another suitable method is the frottage system used in Project 2, in which dry (undiluted) oil pastel is used with tracing paper to make a rubbed impression of a particular texture, which is then simply ironed onto drawing paper.

The painting illustrated here shows many of the characteristics of the medium, but the artist has used it in ways that are specific to his pictorial requirements. This must always be the case in the quest for a personal account of any subject matter — materials and techniques play no more than a secondary role in the total picturemaking activity.

His immediate response to the subject matter was to see it in spatial terms, as large areas of space — the view through the bushes — penetrated by smaller details — those of the flowers and bushes. These aspects were explored by means of the different marks made by the pastel sticks; the sharpened tip will give a very different kind of mark to a blunt one. Incidentally, it should be mentioned that oil pastels become very soft in hot weather, melting to almost the consistency of butter, so for outdoor work in summer the time of day has to be a consideration.

The structure and composition of the picture developed spontaneously and intuitively as the artist worked and became increasingly involved with the subject. Seeing through doing in this way is an important concept, and one that I shall return to throughout the book. Certain forms were omitted while others became more dominant because the picture dictated this.

The colours were chosen to have a relationship with the subject rather than to provide a literal translation of it. The yellow corresponds to the rays of light hitting the dry grass in the middle distance, the greens to fresh leaves, the oranges and browns to flowers and branches. The whole surface of the picture was constantly being adjusted until a cohesive pictorial statement had been achieved. The finished painting has all the verve and vitality of nature, but is far from being a copy of it.

▶ **1** The chosen location, a section of the artist's garden, enabled him to investigate the relationship of positive and negative space – the hedges and the spaces created by looking through them.

◀ **2** From the outset the subject is seen as an abstract arrangement of shapes, requiring no more than a simple, linear drawing before the colour is applied.

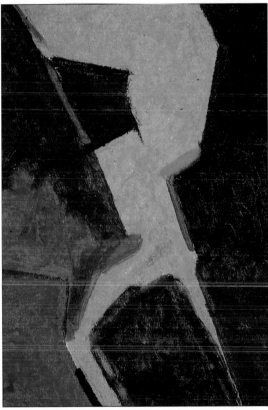

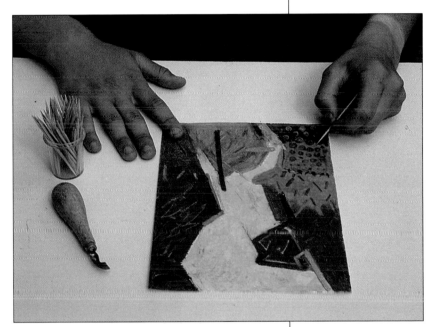

▲ **3** Large, bold areas of colour are now blocked in following the drawn lines of the design. Oil pastel is ideal for laying flat colour, particularly when diluted with turpentine (or white spirit), which effectively turns it into paint. In this case it was applied with a turps-soaked rag. Tonal differences can be achieved by wiping away at the applied colour.

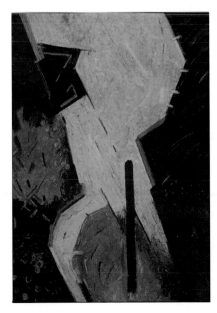

▲ **4** The artist is now using the sgraffito technique to make an area of incised pattern. Oil pastel is particularly well suited to this treatment, as the pigment remains soft, and the top layers are easily scraped away to reveal the underlying colour. The fineness of the line depends on the scraping tool. A toothpick was chosen in this case, but any pointed implement can be used.

◀ **5** Now almost complete, the picture shows an interesting arrangement of shapes and colours combined with texture. The bold, painterly approach demonstrates the richness and versatility of the medium.

PROJECT 5 | OIL PASTEL 2

Using a variety of techniques, Roy Sparkes builds up rich textures and colors.

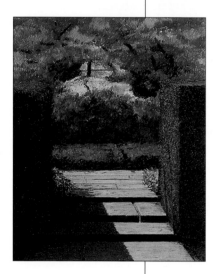

View from the Herb Garden

51.4×41.4cm
(20¼×16⅜in)

Materials & Equipment

Drawing board

Watercolour paper

White spirit

Rags and brushes

Glass slab for mixing

Various scraping tools and points for sgraffito technique

This project contrasts with the previous one by the same artist in that here the landscape subject has been treated in a much more conventional way. The medium, however, is the same, and the two pictures viewed together give an excellent idea of the versatility of oil pastels.

The artist began the picture very much as an oil painter does: by making a preliminary drawing to establish the main shapes and then laying down large areas of colour. Oil pastels can quickly be turned into paint by mixing them with white spirit. This can be done either on the paper itself or on a palette (or glass slab), in which case it can be applied to the paper with brushes, rags or fingers.

The foliage which dominates the back section of the composition was initially blocked in pure yellow, with further colours brushed over it, an effective way of describing the effect of sunlight on thick foliage. The textures of the hedges to right and left have been built up by a combination of base colour washes, stab-like drawn marks of the dry pastel, and sgraffito, the technique of scratching into colour described on the previous page. One of the many attractions of oil pastel is that it allows the painter to use several techniques in the same picture.

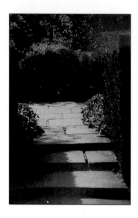

◄ **1** This is a photograph of the location which formed the artist's starting point. The subject was chosen for its strong structural quality and the backcloth of varied foliage.

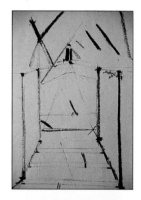

► **2** The main lines of the composition are drawn in rapidly with dark pastel.

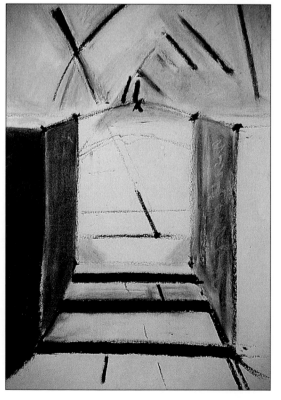

► **3** With the overall design established, the artist now begins to block in large areas of colour to act as a ground for further layers. The intensity of the yellow will be an important feature of the finished picture.

▼ **4** Further colour and detail are now added, and a more specific colour key established.

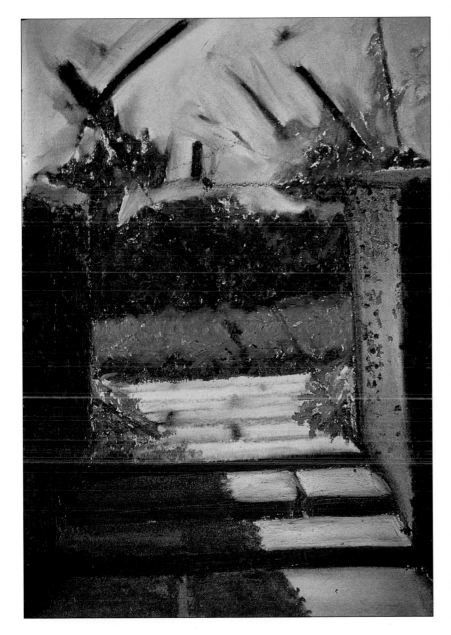

▲ **5** The rich colours are built up by laying layers one over another, either dark over light or vice versa. At this stage the artist has chosen to modify the intense shadow on the staircase while concentrating more fully on the background.

▶ **6** The intense purple-blue shadow on the staircase has now been reinstated, providing a balance for the darker colours being introduced in the background.

◀ **7** This detail shows the extent of the overworking effects that can be achieved in oil pastel.

▼ **8** The sgraffito technique has been used in places to reveal earlier layers of colour.

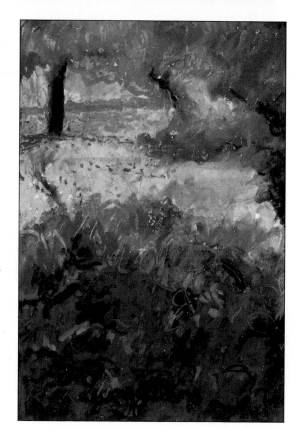

▲ **9** As can be seen from this detail, oil pastel is as sensitive as oil paint, and can achieve extremely subtle nuances of tone and colour.

▶ **10** The sgraffito method is seen at its most effective here, with both the original vivid yellow and an equally vivid deep blue revealed by scratching into later layers of colour.

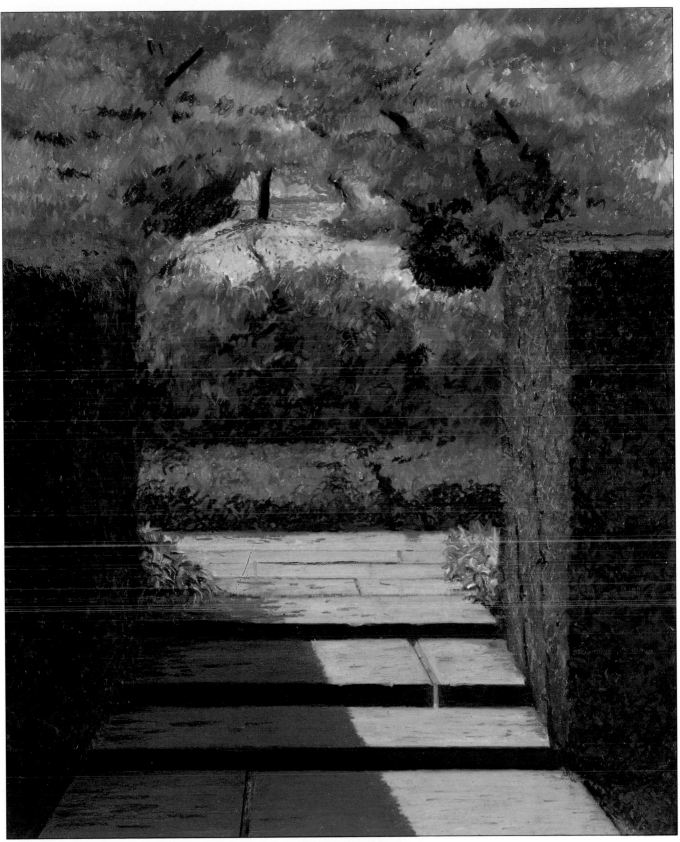

View from the Herb Garden
Roy Sparkes
51.4×41.4cm (20¼×16⅜in)

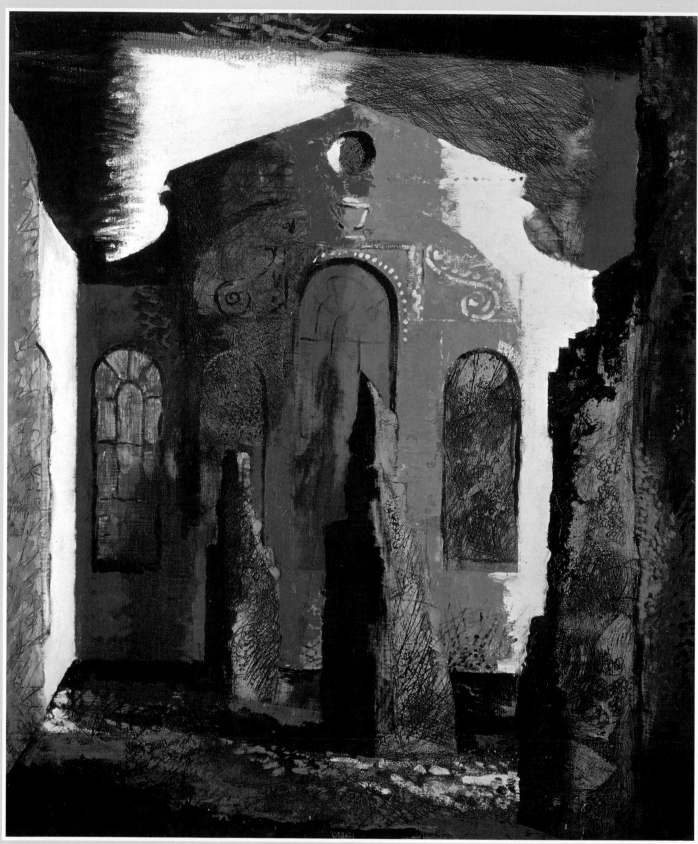

Christic Church, Moorgate
Street, After Demolition
John Piper
1941

Chapter

2

INKS AND
PAINTS

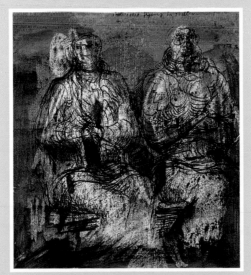

*Two Seated Figures in a
Shelter*
Henry Moore
1941

Ink is a traditional but wonderfully versatile medium that provides the perfect link between drawing and painting.

Previous pages (left)
Piper is an accomplished printmaker, and the cross-fertilization between painting and printing is evident in his inventive mixed-technique painting.

Previous pages (right)
Moore pioneered the use of the wax-resist technique in drawing, and has used it in combination with watercolour and pen and ink to create a powerful effect.

The Cat
Mavernie Cunningham-Fuller 1989

This delightful drawing (below) began as an ink blot, which was then reworked into a loosely representational form.

The previous chapter demonstrated how traditional drawing materials can be used in a thoroughly painterly way. This one takes us further into the realms of painting by examining the "fluid" materials, paint and ink, while still retaining the central idea of the mixed-media approach.

Artist's ink is the medium used for the first two projects, and these lead logically into the next three, which explore the character and uses of oil paint. Nowhere in this book do I attempt to prescribe a set of rules for any one medium, but both students and experienced artists often need to familiarize themselves with a medium before they can exploit it in a more flexible and creative way, and the projects are intended to help you towards an understanding of what can and cannot be done.

Some media, by their very nature, impose certain technical limitations on the user, while in others "anything goes". Only by acquiring the habit of constant experimentation can you find ways of crossing both physical and psychological boundaries to discover ways of working that suit both your individual temperament and the chosen subject matter. You will then be able to embark on the "follow through" process stressed throughout the book, whereby you can apply what you have learned from one picture to a later one, which might be in the next, perhaps in a mixture of media or in an altogether different medium.

INKS

Inks provide a link between the drawing and painting materials, so I shall start with them. Drawing ink – not to be confused with printing ink, which will be discussed later – is a wonderfully fluid and versatile medium. It can be used with a pen for fine lines, or a brush for wider sweeps; it can be applied with a cloth, a sponge or the fingers; it can be blown, dropped or dripped onto paper.

The 19th-century English landscape draughtsman Alexander Cozens, whose sensitive drawings were composed almost entirely from a series of ink blots, devoted a whole book to the subject. He claimed that a group of blots scattered onto paper could produce "an assemblage of accidental shapes from which a drawing may be made". His point was that the blots acted as a stimulus to the imagination by suggesting forms, which could then be developed further, an idea that fits well within the framework of this book.

Long before Cozen's time artists made pen and ink sketches, either as preliminary workings to establish a composition or as part of the information-gathering process. Among the finest are those by Leonardo da Vinci, Albrecht Dürer and Rembrandt which, although made as studies

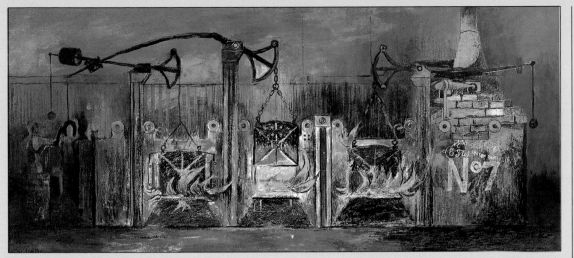

for paintings to be executed in another medium, can be viewed retrospectively as works of art in their own right. It is through the example of such artists that those of the 19th and 20th centuries, among them Van Gogh, Toulouse-Lautrec, Matisse and Picasso, continued to interpret their ideas through this medium.

COLOUR VERSUS BLACK AND WHITE

This seems an appropriate point to correct a common misconception. It is sometimes felt that works in colour are more "important" than those in monochrome, and that the latter cannot claim the status of painting. This is a fallacy. Just as a black and white photograph can be infinitely more descriptive than a colour print, there are times when a monochrome painting approach has an inherent rightness in relation to a certain subject.

Often a simple notation made with a pencil or biro has more visual impact than a grand scheme using a whole kaleidoscope of colours. A good example is one of Leonardo's sketchbook pages, crowded with a variety of different images. These transcend the actual physical marks on paper, so that it is not difficult to see one of these small pages as a composition in its own right.

OIL PAINT

Although the development of acrylic paints in the later part of this century is not without significance for the artist, I have chosen to deal only with oil paint in this chapter. This is simply because, to many, these are the artist's medium *par excellence*.

Oil paint, like all other paint (including pastel) is dry coloured pigment mixed with a binder, and the idea of using oil as the binder is usually credited to the 15th-century Flemish painter Jan Van Eyck.

Initially the new oil paint was used very much like its predecessor, tempera, smooth and thin, with almost invisible brushmarks. However, it was not long before its full potential began to be realized, and it was wonderfully exploited by Titian in the 16th century, who used it inventively and with a true feeling for its inherent qualities. But the most famous name associated with the medium is certainly the great 17th-century master, Rembrandt, who used his paint almost as a modelling medium, building up areas of rich, solid highlight, and often applying paint with a knife or scribbling into it with a brush handle.

Because oil paint is so versatile, every artist who uses it does so in a different way – if one were to see, side by side, one Van Eyck, one Picasso and one Abstract Expressionist painting, in which the paint has been dripped or thrown onto the surface, it would be difficult to believe that the same medium had been used throughout.

There is a great deal of literature on the "correct" use of oil paint, but it would not be relevant to go deeply into the subject here. I have included enough specific information in the projects themselves to help you gain the all-important familiarity with materials that will allow you to develop a feeling for the inter-relationship between them.

PROJECT 6

BLACK DRAWING INK

One of the most traditional materials used in a new and inventive way by Timothy Emlyn Jones.

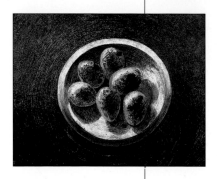

*Stillness at the Centre –
Silence and Flight*
121×152.4cm (48×60in)

Materials & Equipment

Heavy watercolour paper

Household brushes, nailbrush

Shaving brush, wire decorator's brush

Black water-soluble ink

Black waterproof ink

Rags

Swan's quill, bamboo pen

Drawing pens and nibs

Craft knife

Wood saw

This project shows a highly individual working process with black ink, which I hope will give some idea of the flexibility of the medium when coupled with artistic inventiveness. Ink drawing has a long tradition, but one of the disadvantages of tradition is that it can imprison the mind and lead to an approach based on a specific set of formulas which have succeeded in the past.

The relationship between subject matter and approach comes across particularly vividly in this drawing. The artist has chosen to work on a large scale, using heavy watercolour paper (240lbs), which establishes its own physical presence very much as a drawing board or a stretched canvas does. It also allowed him to use a range of different tools with no danger of the paper disintegrating.

There were two main stages in his working procedure, the first being to put visual information on the paper and the second to take some of it off, and it was the interplay of these two processes that allowed him to capture the essential character of the subject. The black, or positive, areas of the picture were begun by applying a large quantity of wash (diluted ink and water) with rag and household brushes of different sizes. Further information was added with various implements, among them a swan's quill, drawing pens, a bamboo pen and a nail brush. The latter allowed large areas to be covered quickly with direction strokes, while the household brushes were used to produce spray marks in specific areas of the picture.

The white, or negative, areas were produced by scratching, carving, scraping and rubbing off the applied ink, this time with sharp implements. A craft knife was used to score the surface of the paper, producing a very sharp, thin line, and an ordinary wood saw was combed across it, resulting in a series of parallel marks. Wire decorators' brushes were also used for some areas.

It should now be obvious why such a strong paper was selected; a lighter one would be severely damaged by such working methods. Some of these techniques can tear even tough paper, but the artist has made a virtue of this and used tears as part of the exploitation of the picture surface. However, there is a risk element in such a physical way of working, and it is not always easy to know how far to go and when to stop. This becomes more obvious with experience, and in any case even pictures that have gone "over the edge" are valuable in the context of learning by experiment.

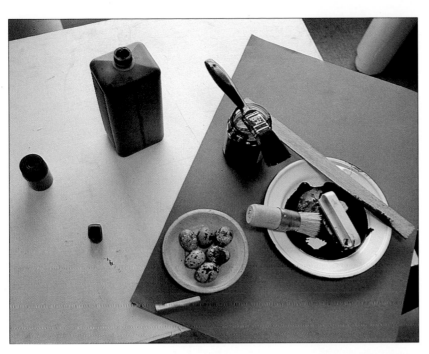

◀ **1** The photograph shows both the materials and the subject matter (the bowl of eggs) used for this drawing. It is a very large-scale work, hence the over-sized container of ink and the household brush.

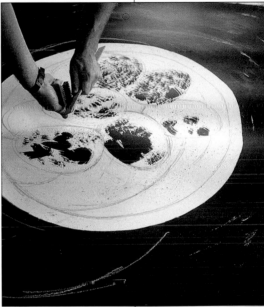

▶ **2** With the paper attached to the wall, the artist has blacked out all the outer areas of the paper with watered ink applied with a household brush and rags. The inner circle has been left clear, and into this he now draws in the shapes of the birds' eggs.

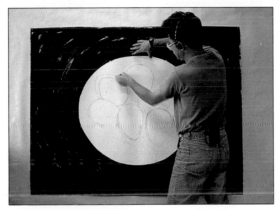

▲ **3** The speckled pattern on the eggs is achieved by a spattering method – that of flicking a flat piece of wood against a nailbrush that has been immersed in the ink wash.

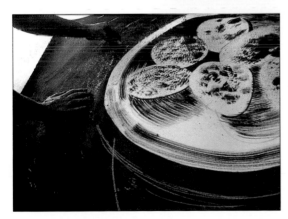

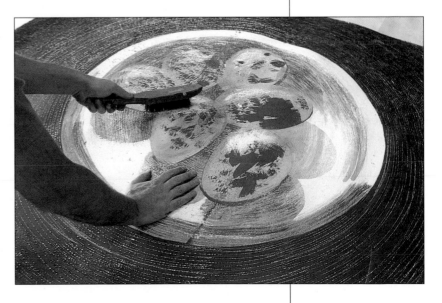

▲ **4** The shape of the bowl is now re-established with white chalk. The chalk lines will not form a permanent feature of the drawing, and will be erased later.

▶ **5** A decorator's wire brush is dragged across the surface of the drawing to produce a continuous series of score marks. A wood saw was also used at this stage to make smaller, coarser marks.

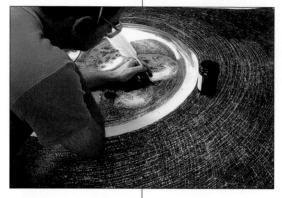

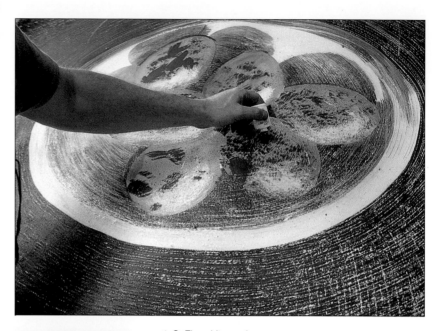

▲ **6** A swan's quill pen is brought into play to add more definite detail to the birds' eggs. The artist cuts his own quills, and is thus able to determine the width of the drawn marks produced. He has also used a bamboo pen, and for very fine lines a pen-holder and fine nibs.

▶ **7** A smaller bottle of ink is used very much as a drawing implement: the size of the bottle's neck determines the shape of the mark produced on the drawing surface.

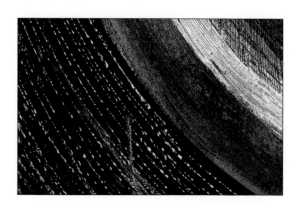

◀ **8** The white marks seen here were produced by scoring the paper with a craft knife. The combination of applying ink and removing it by scoring and scraping is very effective, but the paper used must be strong enough to withstand this kind of treatment.

▶ **9** The variations of scored marks and tonal areas can be clearly seen in this close-up detail of the drawing. The action of the saw and decorator's wire brush continue the circular motif of the bowl itself.

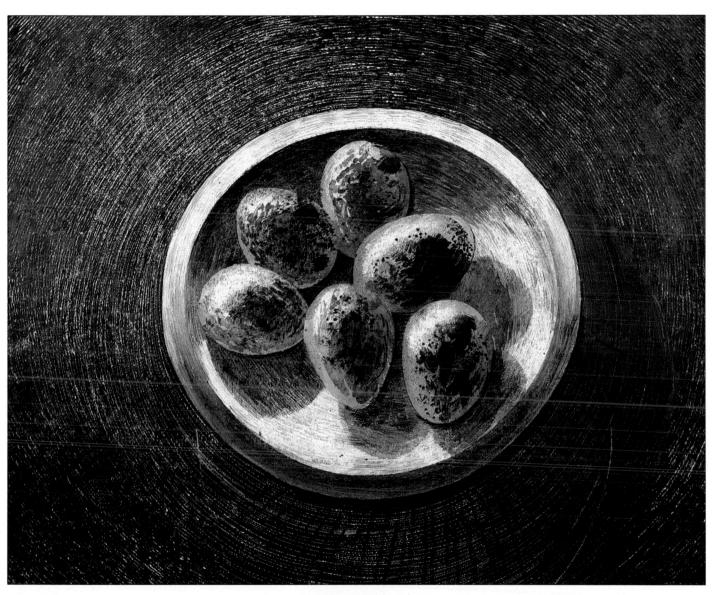

*Stillness at the Centre –
Silence and Flight*
Timothy Emlyn Jones
121×152.4cm (48×60in)

PROJECT 7

INK AND WAX RESIST

David Ferry produces intriguing and unusual effects with ink, bleach, candles and wax crayons.

The Abbey Wall
101.6×71.1cm
(40×28in)

Materials & Equipment

Cartridge paper
Drawing board
Gum strip, masking tape
Fountain pen ink
Household bleach
Wax candle, wax crayons
Artists' coloured inks
Designers' markers
Coloured pencils
Ruler
Cotton wool, rags
Cotton buds
Nylon brushes, toothbrush
Rubber gloves

This took off from the same architectural subject matter as Project 2 in Chapter 1, but because of the fluidity of the medium and the techniques used, the end-result is very different.

The range of inks available from art shops is bewilderingly wide, but there are two main categories, the water-soluble and waterproof (shellac-based), though there is also a new range of inks that can be diluted with water but are waterproof when dry. You will probably need to experiment with dilutions and mixtures to find out the different properties and how they can be exploited.

For the initial stages I used fountain-pen (water-soluble) ink because I intended to bleach certain areas, and this reacts with household bleach in an interesting way. For the resist, I used an ordinary wax candle and wax crayons.

Resist techniques are based on the antipathy of oil and water; ink or watercolour paint will slide off any parts of the picture where wax has been used. Similar effects can be created with artist's masking fluid, but in this case the fluid must be removed when dry, whereas the wax remains as part of the composition. When using wax crayons (or a candle) it is important to think of them as actual drawing materials — the white "resist" marks are a kind of drawing in negative and are very much part of the picture.

Having decided on my composition I drew a simplified version on my stretched-paper support and then drew the window frame and other architectural details with the candle so that the resist was an integral part of the composition from the start. The fountain-pen ink was applied with a cotton-wool ball, rags and for smaller areas a Q-tip.

The bleaching was the next stage. This is an interesting method as it partially removes the ink and creates a variety of fascinating effects. Household bleach is not manufactured for artistic purposes, however, so take care, and do not use expensive brushes as they will quickly disintegrate. Nylon brushes are excellent for the purpose, as are old toothbrushes, rags, cotton wool and a variety of domestic utensils.

Coloured drawing inks were applied over the resist and bleached areas. These are not only wonderfully rich in colour but also transparent, which allows the underlayers to show through to achieve extremely subtle effects of tone and colour.

The final stages were redrawing in certain areas, mainly with coloured pencils, to tighten up the composition and establish a balance between linear drawing and the more painterly methods used earlier.

◄ 1 I began by stretching the paper to prevent it buckling. To do this, immerse the paper in water for a few minutes, place it on a board, and tape the edges with gummed paper strip.

▲ 2 The starting points for this picture were various visual notes and photographs made on location plus a design in my sketchbook. I have decided on the exact dimensions of the picture and marked them out with masking tape. I will work fully up to the tape, which I will remove when the picture is complete. This results in a crisp, clean edge.

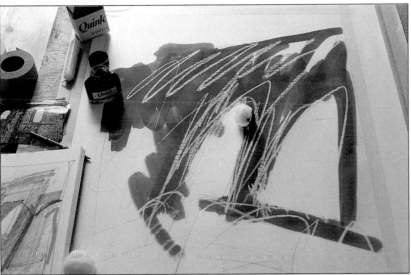

▲ 3 After mapping out the main design in coloured crayon I draw certain key motifs with a wax candle. Water-soluble fountain-pen ink was then applied with a cotton-wool ball over the wax lines, leaving a white line standing out against the black.

► 4 The next stage was to apply domestic household bleach to the inked areas so that the colour was eaten away in places. Note the protective gloves – undiluted bleach can harm the skin.

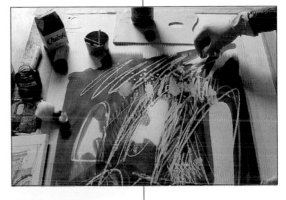

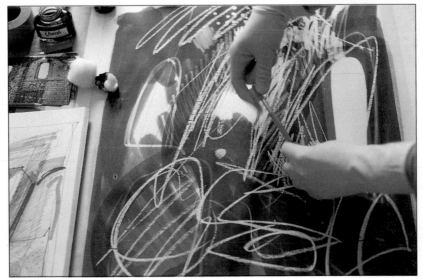

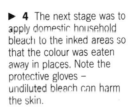

◄ 5 I now use an old toothbrush with the bleach to produce a fine spray-like texture. The overall design of the picture is based on one of the photographs taken on location, so I refer to this as I work, as it helps me to judge where to use the bleach most effectively.

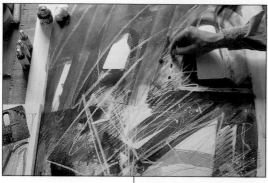

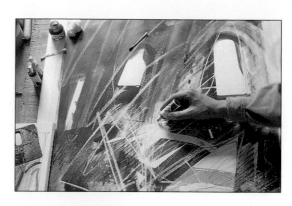

▶ **7** Designers' markers also produce vivid but transparent colour. In this case I wanted a linear effect, for which they are ideal as they are essentially drawing tools.

▲ **6** Previously I have been working only in black and white. I now apply colour with artists' inks, which are highly transparent, an important factor since I do not want to obliterate the underlying texture. The broad areas of colour were applied with brushes, but here a cotton bud is being used to make smaller marks.

◀ **8** This detail of the picture surface shows the effect of both the wax-resist technique and the bleaching. The underlying pencil structure is still visible, as are parts of the initial black fountain-pen work.

▶ **9** The bleaching process can be seen clearly in this area, where it was applied with both the toothbrush and a cotton bud. The window shape was created partly by using masking tape as a barrier. The tape has now been pulled off to leave a clear, straight edge.

▼ **11** The picture is now finished, and the masking tape is removed. The crisp edge was important to the composition which, being very vigorous and textural, required a definite boundary.

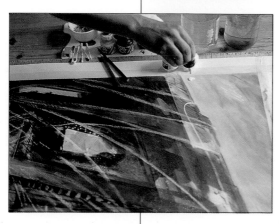

◀ **10** White ink is applied straight from the bottle to create the sky area, The picture is almost complete, but this area is important as it accentuates the red colour of the wall and thus brings the whole composition into focus.

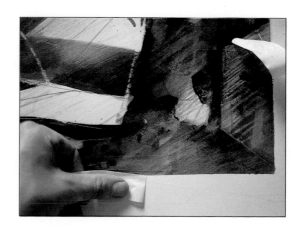

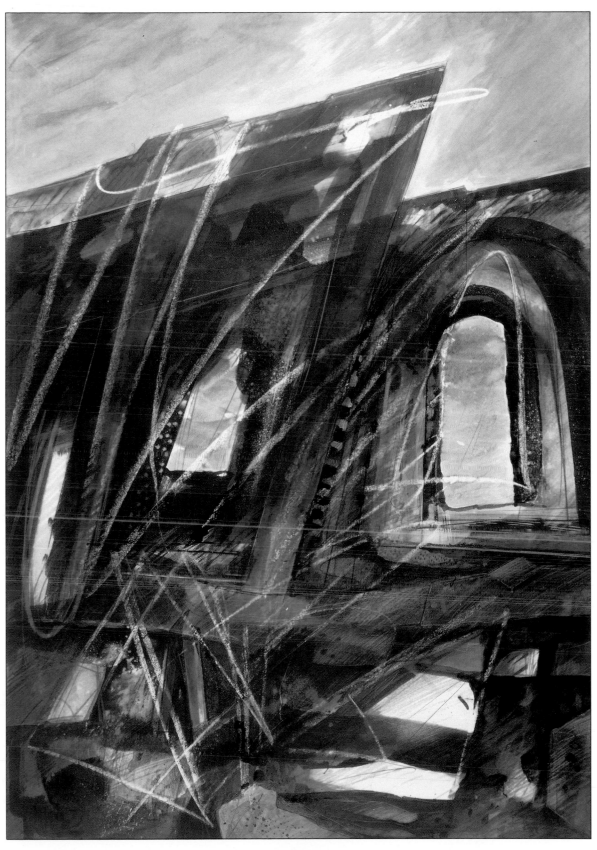

The Abbey Wall
David Ferry
101.6×71.1cm (40×28in)

PROJECT 8

MIXED-TECHNIQUE OIL PAINTING 1

Working directly from life, Peter Clossick uses his oil paint freely and intuitively.

Reclining Figure
127×137.2cm
(50×54in)

Oil paint is perhaps the most flexible and versatile of all painting media, and it is one that no two artists need use in exactly the same way – it can be moulded to suit each one's needs and interests. It also fits well into the context of this book; although brushes are the implements most often used to apply paint, those brought into play here, ranging from painting knives to the fingers, have been part of the artist's repertoire for centuries.

One of the beauties of oil paint is that, unlike watercolour or inks, mistakes can be rectified by simply scraping off the offending area. However, there are things that can and cannot be done, particularly when painting with knives, and this project and the following one demonstrate some working principles which will help you to avoid getting a painting into a ridiculous mess.

Paint can be applied to canvas, board or paper, but the surface should be primed first or the oil will sink in and eventually destroy the fibres. This loss of oil also robs the paint of the thick, buttery quality that allows it to be manipulated so freely.

As far as the painting tools are concerned, there are many things besides brushes and knives that can be used, one of the most sensitive being the hand itself. Fingers are excellent for blending colours together, creating deliberate smudges and smears, even for applying small areas of pure colour straight from the tube. Cardboard scrapers are flexible implements also, and these can be fashioned in such a way as to provide interesting textural passages in paint, such as comb marks.

It may sound contrary, but painting can also be done by pulling paint off the surface. One well-known technique, known as tonking (after Henry Tonks, one-time Professor of London's Slade School of Art) involves using absorbent paper to pull off a top layer of paint. This was originally a correction method, intended to get rid of an unwanted build-up of paint and allow reworking, but it can also be taken a step further and used in a more positive way. Pressing crumpled non-absorbent paper, kitchen foil or rough-weave fabric into wet paint can produce some marvellous textures. You can also scribble into it with a pencil, which creates a series of grooves and ridges, leave it to dry and then scratch into it to create fine white lines – the possibilities for the inventive artist are more or less endless.

THE PAINTING

This particular project was done in a studio, and the artist chose to paint in a series of separate sessions in order to make the most of the stream of natural light, which of course changes as the sun moves round.

He made no preliminary drawing, but began to paint immediately, as he wanted the painting to develop of its own momentum. However, he quickly became aware of the diagonal emphasis of the figure, and this became the dominating aspect of the composition. Most of the larger shapes and forms were painted in very quickly so that the artist could come back to specifics without becoming too obsessed with detail or interfering with the basic design.

The paint was slightly thinned with a 50/50 mixture of white spirit and linseed oil, which made it slightly fluid but thick enough to be applied with knives as well as rags and fingers. It could also be moved around on the canvas surface without running away or soaking in too quickly. The tonking technique was used to remove paint when it became too thick to handle,

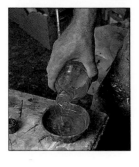

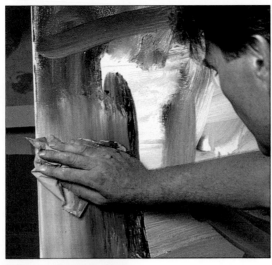

▲ **1** The artist works on a large scale, and mixes his paints on a plastic-coated tabletop rather than the conventional palette. Here he is pouring out linseed oil, used to thin the paint

◄ **2** He begins by spreading out his paints on the tabletop, and then dips a rag into them and uses this to lay large areas of colour on the canvas. At this stage he keeps the paint fairly thin, as it always should be in the early stages.

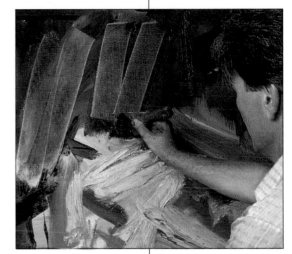

► **3** A wallpaper scraper is now used to make flat but striated areas of colour which form a foundation for later applications.

◄ **4** The artist's equipment includes a large roll of industrial kitchen paper, which he uses for painting, removing areas of paint and for cleaning equipment.

▼ **5** The paint is manipulated in a number of ways, including spreading and gouging with the fingers or thumb, as here.

and further layers were applied until the artist was satisfied with the result.

Because he was in effect "drawing" with paint as well as painting with it, the effect of the finished picture is fresh and spontaneous yet coherent, and the use of a limited palette — Indian red, yellow ochre, ultramarine, black and white — gives it an overall sense of unity. A small range of colours can be a distinct advantage, as too wide a choice on the palette can result in confusion and a disharmonious picture.

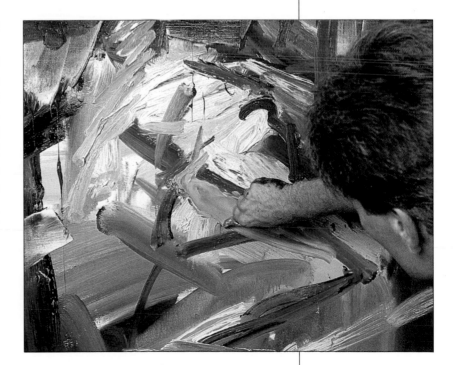

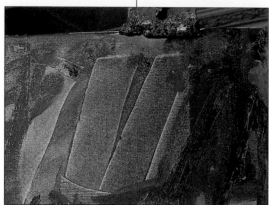

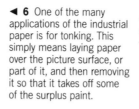

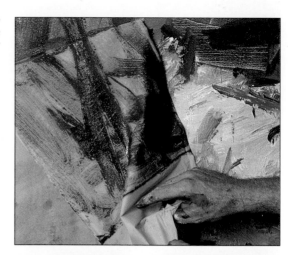

◄ **6** One of the many applications of the industrial paper is for tonking. This simply means laying paper over the picture surface, or part of it, and then removing it so that it takes off some of the surplus paint.

▶ **7** There is often a stage in oil painting when the paint is too heavily built up to allow further working. Tonking also reduces the oil content of the early layers of paint and makes them drier and less liable to become churned up.

▲ **8** This detail of the tonked surface shows the original marks made by the paint scraper. Because the paint was thinly applied in this area it has sunk into the canvas and is not removed by the paper.

▶ **9** The artist has used his fingers extensively in the later stages of the painting. Here he uses his hand very much as a drawing implement to fine up details.

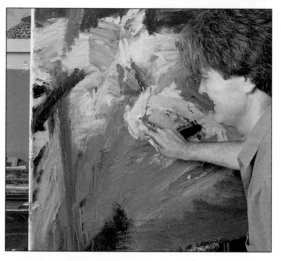

▲ **10** The wallpaper scraper is now used on its side to add touches of linear definition by gouging into the wet paint.

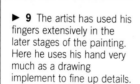

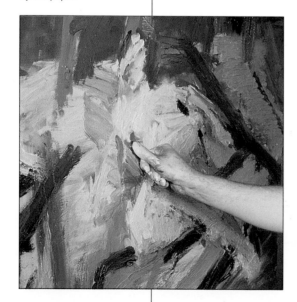

▲ **11** Notice the variety of textures that can be produced by the finger-painting method. The wave pattern on the right is a particularly good example.

▶ **12** A comparison of the painting with the actual set-up shows that in spite of the free treatment the picture is faithful to the subject.

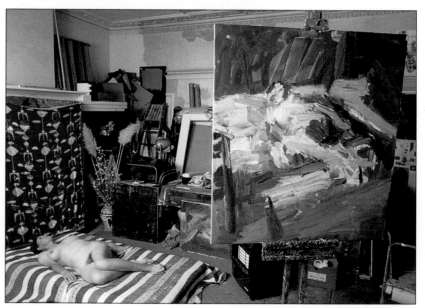

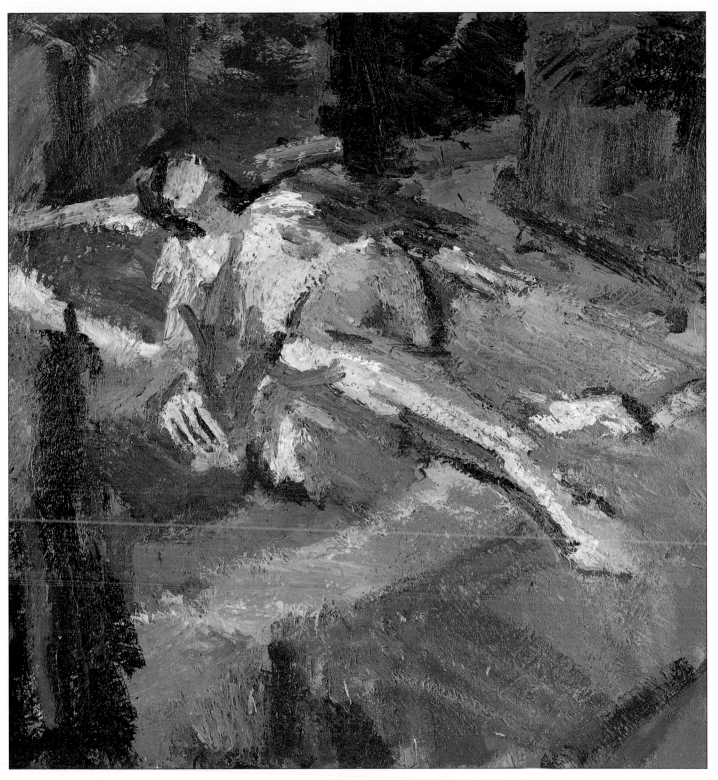

Reclining Figure
Peter Clossick
127×137.2cm (50×54in)

PROJECT 9

MIXED-TECHNIQUE OIL PAINTING 2

Again using unconventional techniques, Peter Clossick recreates a landscape in his studio.

Across Lee Road
50.8×139.7cm
(20×33in)

Although some of the projects in the earlier part of the book were begun and completed out of doors directly from the original inspiration, the main emphasis throughout this book is on using the location (subject) as a starting point from which to develop individual ideas. This project, while treating a conventional urban landscape subject, again shows the artist working in the studio, away from his original inspiration, but basing his painting on direct observation in the form of sketches.

Painting entirely on location, although a valuable exercise, has its drawbacks. Firstly the artist has to cope with changing light and unpredictable weather conditions, both of which can be distracting, and secondly it can be more difficult to express a personal response to a scene when the reality is right in front of your eyes. This is why some artists prefer to recreate the reality in their own way in the studio.

This approach, however, needs careful planning. There are a few fortunate people who have very precise visual memories; one such was the great English landscape painter JMW Turner, who claimed to remember the exact details of a thunderstorm years after he had seen it. Most people, however, although able to retain a general impression of a scene, cannot recall it in enough detail to produce the kind of image shown here.

Thus if the picture is to succeed in terms of description of a particular subject the visual information gathered at the initial stage of a painting must be really informative. Clossick made several studies of this particular view of a surburban street, and through doing so became aware of many subtle nuances of shape, texture and colour. His sketches, together with his initial responses, became the guidelines for his final studio-based picture.

Materials & Equipment

Stretched canvas

Acrylic primer

Oil paint

Rags

Turpentine, linseed oil

Decorating knives and scrapers

Mixing table

▲ **1** Sketches in different media were made before the painting began. This pencil drawing concentrates on line, while others, in softer pencil and charcoal, explored tonal relationships.

▲ **2** Colour sketches such as this, in oil pastel, were particularly important. Several of these were made in order to try out various permutations of colour and shape.

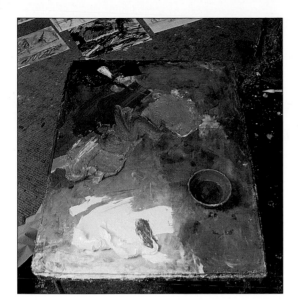

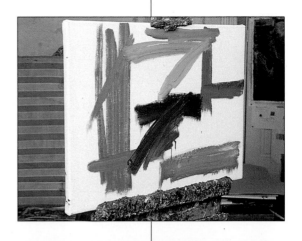

▶ **4** The first marks on the canvas, establishing the structure of the composition, were made with fingers and decorator's paint scrapers.

▲ **3** Some artists like a hand-held palette, while others mix their paint on a table top, as here. The small bowl contains a half-and-half mix of linseed oil and turpentine, used for diluting the oil paint when necessary. Notice also the arrangement of sketches laid out on the studio floor.

▶ **5** Once the main "skeleton" has been blocked in the artist can now proceed with the archetictural motifs.

◀ **6** Large quantities of paint were now mixed up, as the build-up of thick paint (impasto) is a particular feature of Clossick's way of working. Some areas of the picture are almost like low relief, giving a three-dimensional quality to what is basically a flat surface.

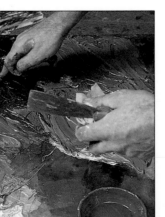

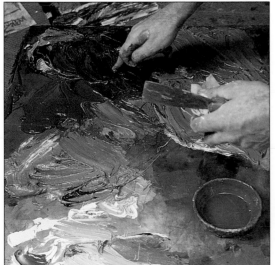

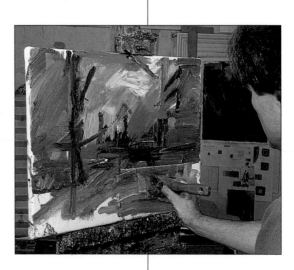

▶ **7** The artist continues to rework the painting until he is satisfied with the result. Here he is using a flat knife to scrape away some of the previously laid down colour before repainting.

PROJECT 10

MIXED-TECHNIQUE OIL PAINTING 3

Finger- and knife-painting methods allow George Rowlett to make personal and expressive statements.

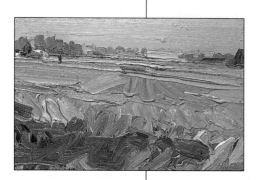

Stubble Fields, Deal Marshes, September Evening

55.9×86.4cm (22×34in)

This project, like the previous two, demonstrates an exciting and highly personal approach to oil painting. Because he uses his paint very thick, Rowlett buys it in large cans rather than the conventional tubes of colour. He works on stretched canvas prepared with acrylic primer, which is suitable for both oils and acrylics (oil pigments can be used on top of acrylic but not vice versa).

For this painting he has used both his fingers and a flat decorator's paint scraper to apply the colour. It is important to point out in this context that technique should never be seen as an end in itself: the artist does not use a knife simply because he or she likes the feel of it, but because it is the best tool to provide the desired effect. Here you can see how Rowlett has expressed both the actual physical contours of the landscape and his own response to it through his solid, almost moulded paint; the picture has such a strong physical presence that we can almost imagine crawling along the furrows of the field, touching and smelling the earth.

Van Gogh's landscapes have many of the same qualities. Although he used the conventional oil painter's brushes rather than knives and fingers, his thick paint and swirling or directional brushstrokes were unlike anything that had been seen before. More than any other artist, he paved the way for later generations to explore their emotions as well as their subject matter through paint.

Materials & Equipment

Stretched canvas

Acrylic primer

Oil paint

Decorating knife and scraper

Turpentine, linseed oil

▶ **1** Some oil painters work slowly and hesitantly, but Rowlett is not among them. Working quickly over the whole canvas, he establishes the main composition and colour relationships immediately. Here he is using a decorator's knife to "feed" large areas of dark colour to the underlying pink areas.

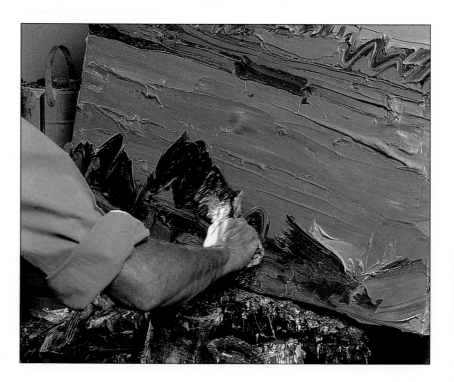

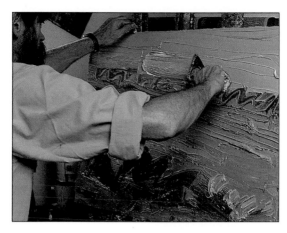

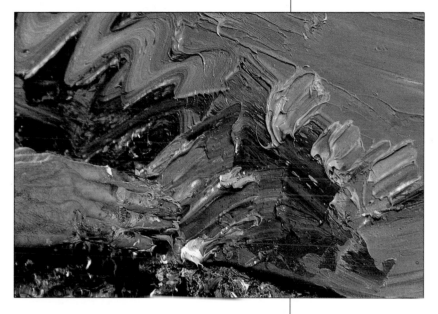

▲ **2** A wide, flat paint scraper (a tool normally used by home decorators) allows him to lay on broad areas of colour. A feature of this picture is the different textures produced by this implement, which flattens and squeeezes the paint, and the fingers, which leave quite a different kind of mark.

▶ **3** Here the artist is working the paint with his fingers, almost modelling it. Extremely subtle and expressive passages of colour and texture can be built up in this way, but the paint must be thick and undiluted. It can be given extra body by mixing with an impasto medium specially sold for the purpose.

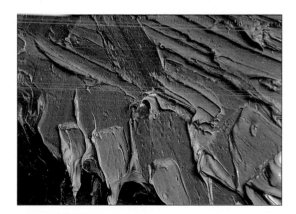

◀ **4** This detail shows how accurately the paint surface mimics that of the landscape itself, with the "track marks" of knives and fingers emulating those of the field. The paint surface is as important in an oil painting as the subject, and here it is an integral part of the composition.

▶ **5** As the painting nears completion the artist uses one finger to define some of the more detailed passages of paint. The sensitivity and precision of this working method can be seen in the final painting opposite.

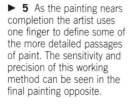

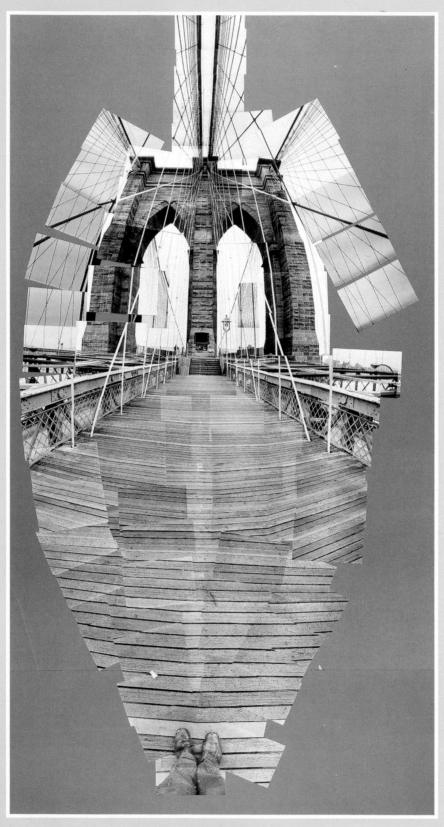

The Brooklyn Bridge
David Hockney
1982

Chapter

3

COLLAGE AND PHOTOMONTAGE

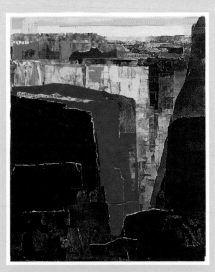

Colorado Canyon
Kathleen Zimmerman
1978

Collage involves piecing together visual ideas and concepts rather than just bits of coloured paper.

The Hotel Eden
Joseph Cornell 1945

Collage need not be restricted to two-dimensional images; in his shallow box display (below) Cornell has juxtaposed two- and three-dimensional objects. The bird is "false", that is, a flat cut-out, but the perch is an actual object.

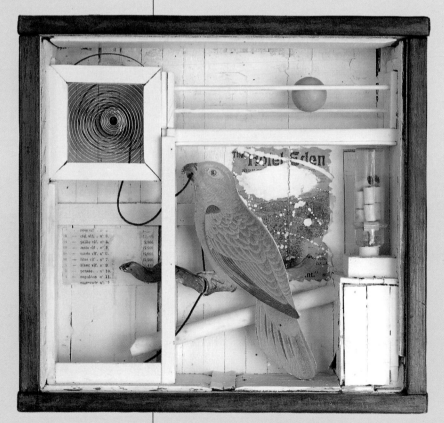

Having dealt in the earlier chapters with the more traditional painting and drawing materials, albeit used in a less than traditional way, we have now reached a stage where the image can be manipulated in other ways. The term "image manipulation" may sound alarming, but all it really means is taking a more lateral and less literal view of the subject matter. It involves thinking around the original conception of an image so that it can be seen in a different context and thus make a completely fresh statement.

A NEW WAY OF SEEING

It is certainly a more intellectual exercise than simply sitting down and drawing or painting what is in front of you, and it does require a certain amount of courage and chance taking, but it is the next logical step forward in creative picturemaking. Collage is a good starting point in the process, because it is so different from "straight" painting that it forces a re-evaluation of concepts and ideas.

As a jumping-off point for the varied projects in this chapter, the first one concerns itself simply with bonding together a selection of previously painted images to form a complete collaged picture. Because we are still at one level dealing with the business of painting, this provides a link between this and the previous chapters, while at the same time leading on into unexplored territory.

As the chapter progresses and opens out we will look at ways in which the photographic image can be used in new and more creative ways. Even if this involves taking the seemingly destructive steps of cutting up or painting over photographs, they will not be destroyed, merely transformed into something with more significance.

Nor need this approach be confined to photographs. Take, for instance, the obvious example of a painting that is not going well. You can throw it away, but you can also take a more constructive attitude and consider reusing it in a different form. Take it off the stretcher or board and make a cut in it – not the angry gesture of frustration but a deliberate and planned act. You will now have taken a step in a new direction by radically altering your original concept, and this may provide some ideas on what to do next.

This is not to say that you will automatically be able to make a successful collage out of the cut-up painting. It may or may not work out, but even if it does not the exercise will have served the purpose of breaking down a barrier and making you think again about the validity of your

previous way of working. Once over this barrier, you can travel freely along the new road presented by collage.

COLLAGE DEFINED

Dictionaries define collage as a method of cutting and glueing paper to form a design or picture, and so it is, but it can be much more than this. Most of us must have made collages at school using crêpe and tissue paper, and most of us probably regarded it as a fairly lighthearted form of picturemaking. I did myself, but now see how misguided I was.

Collage involves piecing together ideas, concepts, visual elements, indeed pieces of experience, rather than just bits of paper, and this, I feel, is at the heart of the creative process. It is about an attitude to art that never plays safe, being prepared to take a risk without embarrassment.

It is possible to see many examples of collage in art history books and major collections. It became an important art form in the Cubist period with the work of George Braque and Picasso, was practised by Max Ernst and other members of the Surrealist Group as well as by the Russian artists Alexander Rodchenco and El Lissitzky. Among the most beautiful collages ever made were those of Henri Matisse who, when he became too ill to hold a brush, was still able to cut and paste coloured paper to create imposing works of art, sometimes on a grand scale.

Collage is central to the *œuvre* of the American painter Robert Motherwell, and special mention should be made of Kurt Schwitters, who made a singular contribution to the art form. His work has had a great influence on the modern attitude towards collage, so that it is now seen, not as a diversion or an addition to other forms of image-making, but as an art form in its own right.

However, as a mental activity, the idea of collage is not always easy to grasp. To make collages is to enter a world of speculation, where excitement goes hand in hand with uncertainty. It differs from any other kind of picturemaking in

that the idea for the final picture may not be arrived at until the very last moment. Normal time and space can be suspended, or even fractured, by juxtaposing elements from different sources or periods in history, so that a completely new reality is formed.

THE MATERIALS

Photographic collage is as old as photography itself, and was not originally confined to the artist. Comic postcards pasted into scrapbooks; photographs and colour prints cut out and pasted onto screens; the illustrations from picture books used as wallpaper, all belong to the category of collaged image-making.

Exactly the same things can be used today, and there is no reason why you should not employ the camera as a deliberate first step in the process, as David Hockney does (see pages 11 and 50). But the list of possible ingredients for this art form is more or less endless — playing cards, fabrics, plastics and packing materials, newspapers, magazines, book jackets and natural materials such as grasses, flowers and seashells are just some of the possibilities. Once you have become aware of the potentialities of collage-making you will begin to see the materials all around you.

Magnetic Moths
Roland Penrose 1938

Among the fragments used for this collage are ordinary picture postcards. The multiple use of these is similar to that of Hockney's Polaroids (see page 50), but the visual effect is quite different, as in this case each multiple creates its own shape and form. Penrose has combined collage with frottage, seen in the flame-like shape at top right.

PROJECT 11

PAINTED COLLAGE

Nicola Rae demonstrates her approach to collage — her techniques have evolved from personal experimentation.

Sun, Fish and Buildings, Dieppe

50.8×45.7cm (20×18in)

Materials & Equipment

Oil paint, gold paint

Oil pastel, 6B pencil

Cotton duck (canvas), calico (thin canvas)

Stretchers, plywood

PVA glue

Craft knife, scissors

Painting knife, fine brush, modelling tool

Compasses, protractor, ruler

Cardboard for template

Up to this point all the projects have used fairly traditional artist's materials, although not always in the most obvious ways. This one retains a link with the earlier chapters because the artist has chosen to use the materials and techniques of the oil painter. What she has produced, however, is not so much a painting as a collective tribute to the shapes, forms and textures that were her initial inspiration.

The chosen support for the collage was a stretched canvas (cotton duck) primed with PVA glue, which is transparent and thus does not change the colour of the material. The images themselves, however, were not formed on this but on a separate piece of canvas — in this case calico — stretched over plywood and taped at the back to keep it in place.

Platforms of oil paint were applied on the calico with a painting knife, and then scratched into with a modelling tool. These were allowed to dry before being cut out and pasted onto the "master" canvas with the same glue used for the priming. These platforms of colour can also be used in a kind of sandwich by laying a piece of muslin over the dried paint and then applying a coat of PVA glue. This softens the colour and makes an interesting contrast in texture.

Another of the artist's variations in technique was to apply a second layer of oil paint over the first (when dry) and then scratch through the wet top layer to reveal a line of the other colour below. This is a well-known method called sgraffito, used in both oil painting and oil pastel work.

The sun shape was carefully plotted out with compasses and a protractor, after which a cardboard template of the rays was made and drawn around. Picture restorer's gold paint was used for the colour, and the whole thing was then cut out with a craft knife.

The beauty of this kind of picturemaking is that you can make as many experiments as you like before assembling the collage. Images do not have to be glued into position until various arrangements have been tried out. In this case the artist had a fairly definite idea of the finished picture, and had chosen the format of the canvas accordingly, but you will often find a collage taking shape as you work.

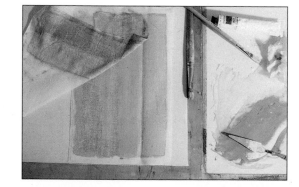

▲ **1** The artist began by preparing a traditional oil-painting canvas, although this is not used until a later stage in the picture; it will form the base of the collage. Here a piece of muslin which has been painted over with oil paint is pulled off a prepared panel of calico on board to give a sensitive layer of texture. Eventually the whole layer of calico will be cut out and glued to the canvas.

► **2** The calico panels will be painted before being cut out and glued to the canvas base. Here the artist is drawing into oil paint which has been spread over thin muslin. This in turn is glued onto the calico, so that each panel becomes a kind of sandwich of visual information.

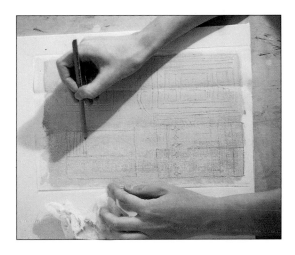

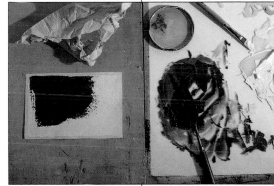

▲ **3** Cobalt blue is applied over a layer of pale yellow which has been allowed to dry. This is a preparation for the sgraffito technique seen in the next photograph.

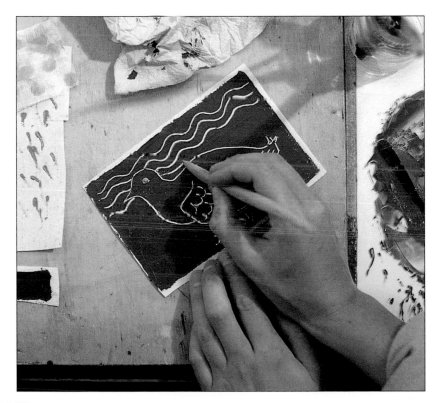

▲ **4** Scratching into the wet blue paint with a pointed implement makes a crisp, clear line of pale yellow (the underlying colour). Any mistakes can be easily rectified by simply re-spreading the blue colour with a palette knife.

► **5** The artist uses a variety of different painting techniques for the calico panels to give a textural dimension to the finished image. When completed they are cut off the board, glued on the back with PVA glue, and lightly pressed onto the surface of the primed canvas.

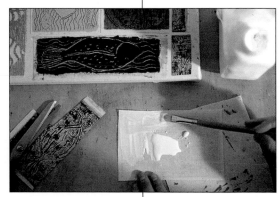

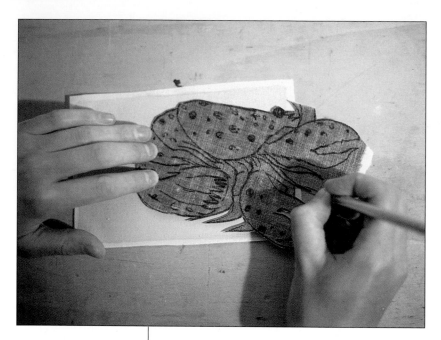

◄ **6** The image of the lobster is carefully cut out with a scalpel preparatory to glueing down. The texture of the muslin can be seen clearly here.

▼ **7** Not all the panels bear specific images; this one is simply a pattern of stripes, with the muslin fabric creating a subtle woven texture.

► **8** This image was made by a version of the monoprint technique (see Chapter 6). A blue block of oil colour was covered with muslin and allowed to dry. A second panel with the sgraffito image of a fish was placed over it while still wet, resulting in a sensitive and unusual printed image.

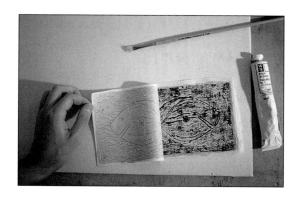

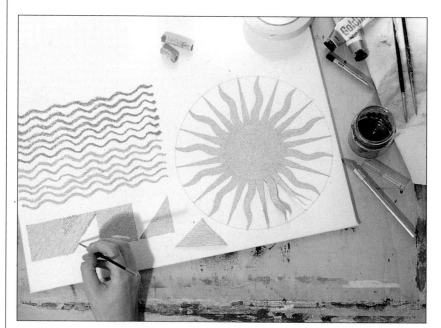

◄ **9** A pair of compasses was used for the outer circle of the sun, and a protractor for the triangular shapes behind it. The sun was painted with picture restorer's gold paint, left to dry and then carefully cut out with a scalpel. The wavy lines were made with grey and gold oil crayons and a fine brush. These were painted directly on the calico panel and then cut out and glued onto the base canvas.

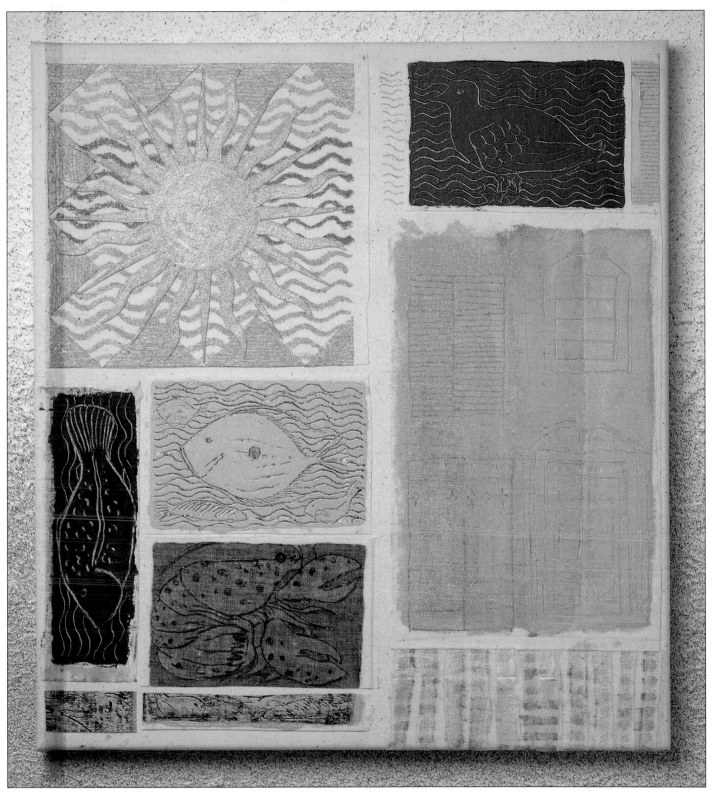

Sun, Fish and Buildings,
Dieppe
Nicola Rae
50.8×45.7cm (20×18in)

PROJECT 12

PAPER COLLAGE

*Magazine photographs and colored paper form the basis for
David Ferry's collage composition.*

The Gate House
88.9×63.5cm (35×25in)

Materials & Equipment

Drawing board

*White and coloured
cartridge paper*

Magazines

Coloured pencils

Ruler

Scissors, craft knife

PVA glue

This, in contrast to the previous project, uses nothing more complex than bought coloured paper, magazine illustrations chosen primarily for their colour content and a few crayons. It is not the quality of the materials but the way they are deployed that makes a collage successful, and working with basic, simple ones such as these can be a wonderfully liberating experience for both the professional artist and the novice.

An important thing to bear in mind when using paper as the main ingredient is that it can either be cut or torn, and the contrast between these two different edges can be very effective. A cut edge or shape has a deliberate and definite look and carries a certain air of authority as well as providing crispness of definition, while a torn edge can be expressive, lively and evocative. Paper can also, of course, be drawn on after collaging, which allows you to add a further linear dimension to complement the different kinds of edges and shapes.

The starting point for this image was a photographic collage made from some of the material gathered for Project 1, which acted as my "working sketch". Using this as a guide, I began by drawing a rough design on the paper with coloured pencils, which I intended to use again in the later stages to add texture in certain areas.

I then made some basic descisions about which pieces of coloured paper to use for each separate element in the design. This can be done before anything is glued down; indeed it is wise to try out different permutations on a table or working surface before committing yourself. In this case I only glued down the large areas of base colour for sky, building and foreground after trying out several different arrangements.

Once these were in place I had the basic structure, and could consider the arrangement of the various elements, and in particular the size relationship of the figures. Those in the background were kept very simple, cut out in one piece, as I wanted to give prominence to the foreground figure in terms of both size and detail. My "working" photographic collage came into its own again here, as I was able to refer to it for ideas about converting specific detail into collage.

When the main subject areas are glued down in position, further small passages of detail or texture can be added where extra interest is needed. It can be difficult to know when to stop, but this applies to any picturemaking activity and is something that comes with experience. If you find this a problem, it may help to put the work aside for a day or two and then reassess it with a fresh eye.

◄ **1** The photograph shows the main components for this collage, with my earlier sketchbook collage in the centre. This, which was made from photographs used as research in earlier projects, serves as a blueprint for the much larger work.

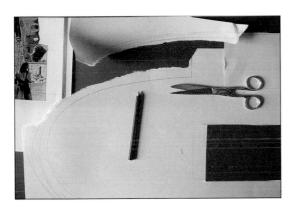

◄ **2** I always begin by planning out the design, and in this case I made a diagrammatic line drawing on ordinary cartridge paper. This design was then cut and torn and placed over the red paper. Even at this stage the characteristic edge and shape of the ruined gatehouse was apparent. Collage fragments need not be glued down until much later in the proceedings, but I chose to stick this down now to avoid too many elements coming together at the same time.

▲ **3** Once the main structure has been established, I can begin to consider the details, such as this figure cut from a larger photograph. I chose the area in the middle because it gives the effect of drapery.

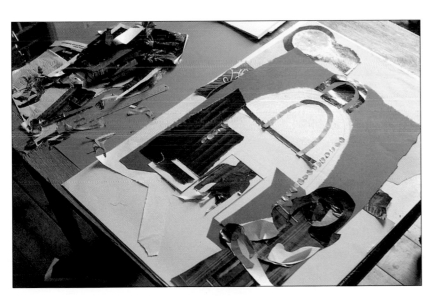

▲ **4** The main figure was constructed from many separate collage elements. This and the red gate house shape are now placed on a green base. All the main compositional elements are now in position and can be glued down.

▶ **5** Often the selection of collage material presents itself quite naturally, for example the close-up of the soluble pain killer was the perfect sun motif. This photograph also shows the effective use of cut and torn edges, an important element in paper collage.

PROJECT 13

MIXED-TECHNIQUE COLLAGE

In this mixed-media tour de force David Ferry has combined collage with stencils, spray paint and drawing.

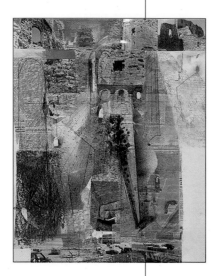

The Eleventh Hour
81.3×61cm (32×24in)

Materials & Equipment

Drawing board, glass slab

Cartridge paper (base for collage)

Card (for stencils)

Photographs, magazines, newspaper pages, texture rubbings

PVA glue, glue stick

Pencils, ruler, magic markers, oil pastels

Scissors, craft knife, small screwdriver

Spray paint, acrylic paint

Rags, brushes

The two previous projects took us some way from conventional picturemaking, that is, from the widely accepted notion of looking at a scene or subject from a single viewpoint. In Project 11, the painted collage, each component was prepared with the end-result in mind and then moved around and rearranged to form the overall design. In Project 12 cut and torn coloured paper was used as the basis for the composition. This combines the two methods in that some of the elements are painted, while others are existing images on paper in the form of photographic material and newspaper texts.

One of the trickiest aspects of this kind of collage is choosing a selection of parts that will fit naturally together to form a balanced whole. This will probably involve some trial and error, at least initially.

Paper collage fragments can be virtually anything: plain paper, newsprint, photographs, tissue paper and tracing paper are just some of the possibilities. For this picture, I have also included some of the oil crayon rubbings on tracing paper, first used in Project 2.

Having made a selection of the components, my first step was to plot the general composition in my notebook, after which I drew a simple structural diagram onto a piece of paper and began, slowly and carefully, to glue the fragments onto it.

There is always a chance element in collage, indeed this is one of its most attractive aspects, and I may not adhere to the original choice. But even if I react to something else that happens to be around the working area and decide to incorporate it, I find the underlying working drawing gives a sense of structure to the operation. This is particularly important when dealing with so many disparate elements.

The main form of the collage was established by the glued-down paper fragments, and the final stage was putting on the colour to correspond with my original reactions to the subject, or location. This was an exciting stage in the development of the picture, and I used several different techniques, including stencils and spray paint, but restricted the colour to water-based paints and inks to avoid the possibility of leaving an oily stain on the paper. Finally, I re-established the drawing with a ruler and coloured pencil, giving an ordered, linear quality to balance the structured appearance of the newsprint.

▲ **1** The photograph shows a selection of collage material spread out on my working table before being edited. Because the subject matter is architectural I intend to use some of the frottaged textures collected earlier (see Projects 1 and 2).

► **2** Having made a more discriminating selection of matrerial I start to consider its arrangement on the picture surface. Already pictorial relationships are forming, with the tracing paper rubbing placed alongside one of my photographs of the location. Both these will remain as elements in the final collage.

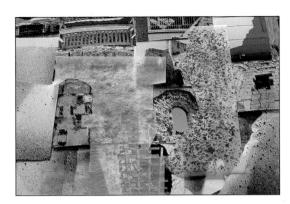

▼ **3** As yet I have not glued any of the collage components in place. At this early stage I prefer to place a glass sheet over the collage, which allows me to view it while avoiding the danger of the pieces being accidentally shifted.

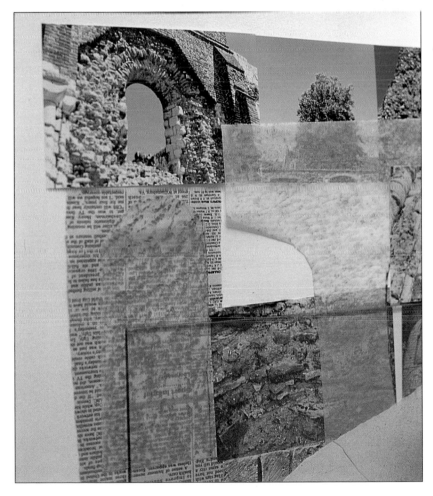

▲ **4** After some "fine tuning" I now glue down the areas I am satisfied with. The glass slab still holds the un-glued collage fragments.

► **5** The more intricate pieces of collage are difficult to tear, hence the use of scissors here. I shall use a glue stick to secure these to the base paper.

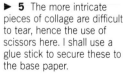

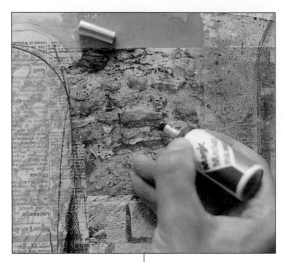

▲ **6** Magic markers are excellent for introducing delicate touches of colour, particularly when photographic elements are involved. The colour sits well on photographic paper, and since it is transparent it does not obscure the underlying image.

▶ **7** I am now re-establishing some of the basic structure of the collage. Sometimes certain aspects become disjointed, or are overlaid in the glueing and selecion process. To unify the whole image I am taking the architecture of certain motifs through and beyond the specific fragment.

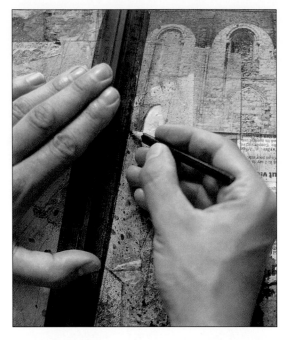

▲ **8** Certain shapes are built up with spray paint and a cardboard mask or template. The paint produces a slightly embossed effect, and the simple window shape, once cut, can be repeated in other areas of the collage.

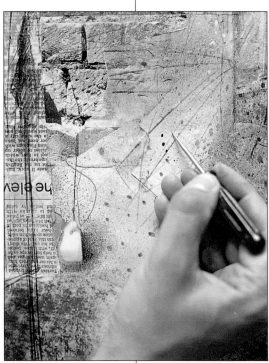

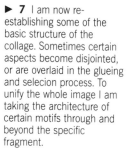

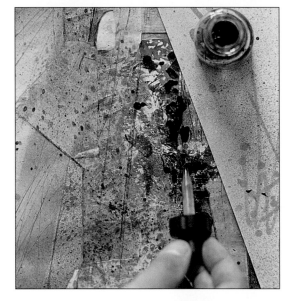

▲ **9** Spray paint can be scored into before it is fully dry, allowing underlying areas of colour to show through. I am using a small electrical screwdriver to produce thin scratched marks in contrast to the heavier shapes alongside.

▲ **10** I now apply ink, dropping it on with the dipper of the ink pot. Once on the surface the ink can be moved around with brushes or rags in whatever way you choose, or simply left as it is. The cardboard strip on the right acts both as a portable palette on which I test colours for each area of the collage and as a mask to protect the parts not being worked on.

▼ **11** Oil crayons have produced a light veil of colour and texture on certain areas. With the collage virtually complete, I then placed it under large boards with weights on top to ensure that all the fragments were well secured. This also flattened out areas where water-based colour had been applied, which can cause cockling and creases.

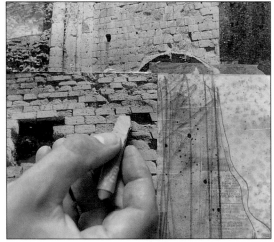

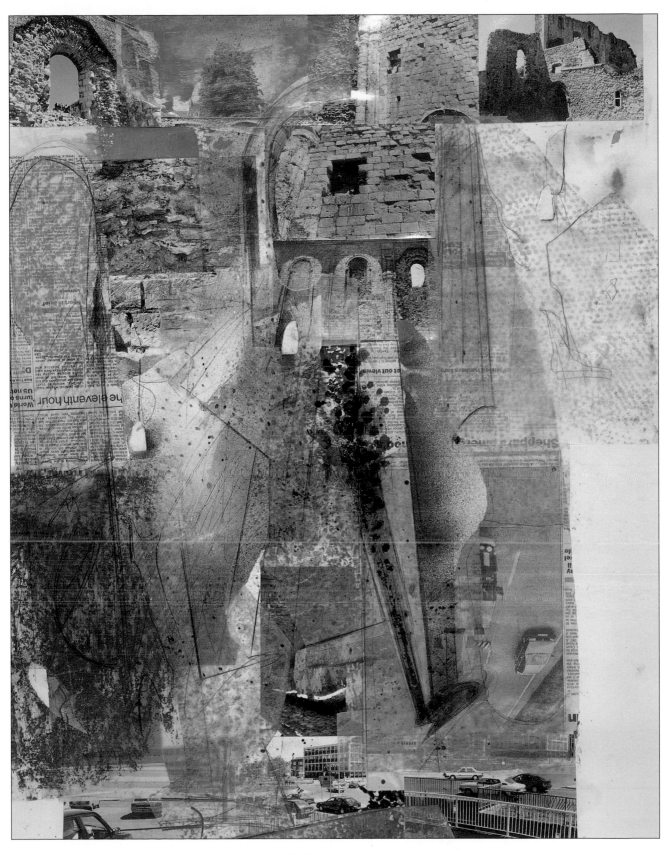

The Eleventh Hour
David Ferry
81.3×61cm (32×24in)

PHOTOGRAPHIC COLLAGE

A simple cutting and pasting process allows David Ferry to create new images from ordinary color prints.

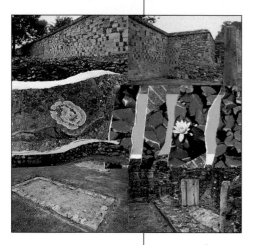

Lichen and Lily

27.9×30.5cm (11×12in)

In case you are wondering whether you will have to come to grips with yet another skill, photography, don't worry – a collage like this requires no expertise in this field. You do not even need to own a camera, as photographic material is all around us, in newspapers, magazines and even food packaging. However, if you want to make a collage representing a certain place or some other subject matter that appeals to you, having a camera does allow you to gather more personal information, so the examples shown here do use specially taken photographs of particular locations.

For this project, I have taken as my starting point several separate "pieces of reality", i.e. photographs, and have rearranged and combined them to form a completely new image. This may sound complex, but basically it is a simple cutting and pasting process, and one which allows you to explore different pictorial possibilities and ways of "reading" images and scenes.

The two collages shown here, for example, heighten our awareness of such compositional devices as layers, verticals and horizontals, shapes and colour relationships. This kind of collaging activity can also be used as the first step towards planning a work in another media. It need not necessarily be seen as a means of producing works in their own right, though it is certainly a good way of doing so.

Such ordinary subjects as a family holiday or outing can be heightened by collaging a set of photographs taken at the time. The great advantage of modern fast colour printing is that you can order a second set of photographs either at the same time as the first or whenever you like thereafter. This opens up tremendous possibilities; you can be as creative as you like with the second set, while the first remains intact.

There are no ground rules for photographic collages. They can be one-offs or be done in sets; they can carry a message of some kind, or they can simply be visually interesting. They can also be whatever size you choose, as the more photographs you use the larger the finished image will be.

If you begin with photographic enlargements rather than the standard-sized prints used here you can make quite an extensive picture with only a few images. The following chapter provides some advice on using "high street technology" to make photostats and enlarged copies of photographic material, which offers even more possibilities for the creative use of what are basically machine-made images.

Materials & Equipment

Colour prints

Scapel, scissors, pinking shears

Ruler

Coloured paper, card for mounting

Glue

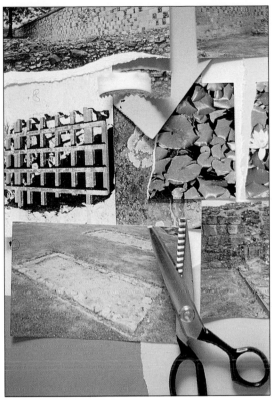

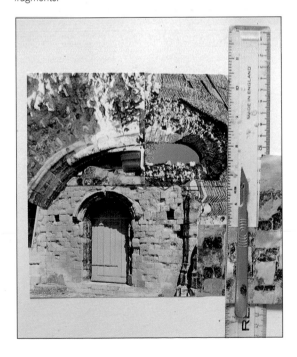

▲ **1** The "Lichen and Lily" collage was composed almost entirely from photographic fragments – standard-sized colour prints – though coloured paper was used as a background for certain areas of the composition. Pinking shears add an interesting textural dimension to the cut fragments.

▼ **2** The coloured paper is now inserted between areas of torn photograph. Many different permutations can be tried before making a final decision.

► **3** Collages like these are relatively quick, so I work on two at the same time. Here you see the fragments of the "Arch Fragments" collage being cut and assembled. Ordinary scissors were used to cut out specific motifs in the prints.

◄ **4** Now almost complete, the collage is cropped around the edges with a sharp scalpel. This was a purely aesthetic consideration; the collage was not required to be any specific size.

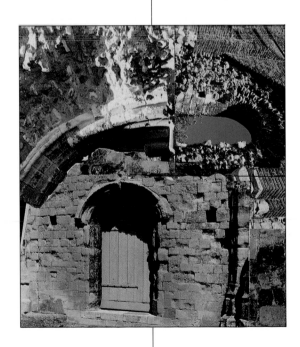

► **5** Both the "Arch Fragments" shown here and "Lichen and Lily" illustrated opposite were very simply made. The most important stages are choosing the components and working out the overall design.

Untitled
Jonathan Hitchen
c.1990

Chapter

4

PHOTOCOPIER
TECHNOLOGY

Heirlooms
Matthew Bourne
1990

Previous pages (left)
Jonathan Hitchen is
currently experimenting with
the artistic possibilities of
the laser colour copier.
Illustrated are two of his
working proofs. Many subtle
and expressive variations of
tone and colour can be
achieved by manipulation of
the machine's controls.

Previous pages (right)
This photocopy collage was
formed from single-colour
copies taken from the same
image, and the central
passage was made by the
dye-transfer method
explained in Project 20.

*Photocopier technology can help us expand our visual range
— exciting results can be achieved from simple beginnings.*

The previous chapter provided an introduction to the idea of creating pictures and images by a system of imposition and juxtaposition. Here both the idea and the working methods are similar, but the range of possibilities is extended, because now we are harnessing art to technology, in the form of the photocopying machine and the new laser colour printer.

This may seem a contradiction in terms to those who have previously regarded art as an inspired alliance between eye and hand in which any mechanical process is an intrusion. Actually, however, it is a logical progression from photographic collage, which also makes use of a technology, albeit a less modern one. As artists, we must learn to turn everything society offers to our own ends, and if technology can help extend our visual and imaginative range, then it is of value.

XEROGRAPHY

Not all the technology mentioned in this chapter is strictly speaking new; the basic process of the copy machine was discovered as long ago as 1935 by an American named Chester F. Carlson. He called his invention xerography, a word derived from the Greek, meaning dry writing. It was not until 1947, however, that a business enterprise, the Haloid Company (which later became the Xerox Corporation) began to support research into the process, and the first commercial equipment was introduced in 1950. The Xerox 914, the first photocopying machine that was widely accessible to the public, appeared ten years later.

At this stage, artists started to take a serious interest in it. By the 1970s, important art institutions such as the Museum of Modern Art in New York had begun to acquire examples of art made from these machines, known alternatively as "copy art", "the xerograph" or "xerography".

Contemporary artists who have used or still do use the technology include David Hockney, who has also recently been making work from the Fax machine, the English artist Helen Chadwick, who has had work purchased by the Victoria and Albert Museum in London, and the American Sonia Sheridan.

THE MACHINERY

The projects in this chapter are not restricted to xerography, however. Three of the projects make use of the photocopier as a basis for collage, each time used in a different way, while another examines another of the services now available in

The Rome Notebook
David Ferry 1989

This (right) began with a straightforward photographic collage, which was enlarged and then reduced on the photocopier. The most interesting passages were collaged again to produce a piece of "artwork", which was photocopied once again on ivory-tinted paper. It became one page of an album of collages based on the art and architecture of Rome.

most town high streets – the laser printer, the latest achievement in full-colour copying. The idea of using this complex machinery may sound daunting, but in fact it could not be easier. You do not need to know anything about the internal workings of either the copier or the laser printer, indeed I feel that ignorance is a distinct advantage, as it leaves the mind open for speculation. Unlike the camera, which can be an extension to the artist's eye, the function of a copying machine is no more than its name implies – to copy.

But images do not have to be the same size as the original; copiers and printers can also enlarge or reduce. The final project in the chapter exploits this capacity by taking a small-scale image and blowing it up to a much larger size on the photocopier. This highlights its creative possibilities: although I have said that it does no more than copy, it also produces marvellous textures which become more pronounced with each successive enlargement.

The final outcome of this process can take any form you choose: the image can be worked on further to create something different, or it can be allowed to stand as something in its own right, an extension of the original idea.

The Rome Notebook
David Ferry 1989

A photocopy collage from the same album, using both black and white and colour machines. The underlying architectural motif was a black and white copy, to which colour was added with watercolour, wax resist and oil pastel. This was then recopied on the laser colour printer.

PROJECT
15

PHOTOCOPY COLLAGE

David Ferry demonstrates one of the many ways in which photocopy technology can extend our visual range.

Flakes of History
41.9×29.8cm
(16½×11¾in)

Materials & Equipment

Original photographic collage

Newspaper pages

Board, glue

Scissors, ruler

Typewriter correction pen

Black/grey markers

White oil pastel

Acetate film

Piece of woollen fabric

Woven-texture paper (for final photocopies)

Oil pastels

Biros, coloured ink, coloured markers

Fine brush, cotton buds

For this project I used one of the photographic collages from Project 14 as a starting point. The image had to be strong enough to allow extra drawing and texture to be added without destroying the picture. I first made a same-size copy, then a 50 per cent enlargement, then another enlargement from the second stage.

Already there was sufficient material to use as the basis of a composition, and the enlargements showed the strong texture that is one of the most attractive features of this process. This can be exploited through a number of different materials: you can make enlarged copies of pieces of fabric, silver foil, cling film, cut and torn paper or a whole range of natural objects such as leaves, twigs and grasses, any of which can be placed directly on the bed of the machine, separately or together. You cannot always predict the precise outcome, but the results are always intriguing, so the more you experiment the better.

Having collected my "texture only" copies of the original, I assembled them in collage form — any of the collage techniques can be used for this process — and then took a further copy from the collage. At this stage I had no clear idea of the end result, but allowed the photocopy itself to suggest to me what I should do next. I find certain materials invaluable at this further working stage — a fibre-tip pen and markers for new drawing and darkening flat areas, and a Tippex pen (typewriting correction pen) for adding new light ones.

The reworked collage, or photocopy artwork, was then ready for copying once again. The choice of paper is an important factor here — there is no need to restrict yourself to plain white.

I chose a buff-coloured paper with a woven texture, which provided an interesting extra dimension.

This new copy constituted one finished image, but with a process like this there is never a definitive end; you can always go one step further. I explored further possibilities by placing a sheet of transparent acetate film on top of the "artwork" and drawing over the image with a black pen. Oil or wax crayons could also be used. I then placed the whole sandwich on the machine again and took another copy. Both versions are shown here, and you can see the difference between them. Nor does the story end here; Project 17 is yet another development of original artwork, this time using the full-colour copier.

▼ **1** One of the photographic collages from the previous project formed the starting for this one. Part of the image was photocopied in black and white on A3 paper and considerably enlarged.

▶ **2** This enlargement was glued onto board to give a firm base for further reworking and collage. Here I am using black and grey markers to add subtle tints of tone.

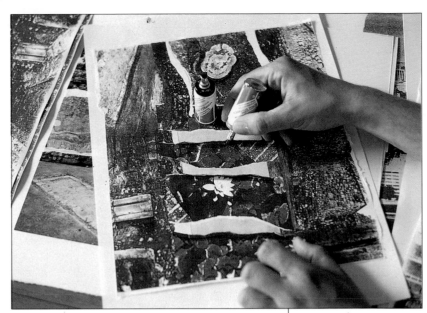

▶ **3** Newspaper elements are now being added to the basic artwork. The photographic quality of a newspaper image is quite different to that of a photograph, and when both are combined they produce an interesting contrast of tone and texture. Another factor is the juxtaposition of torn and cut edges.

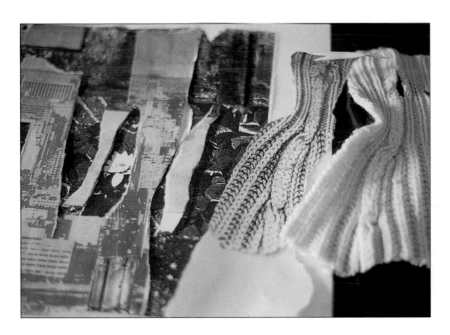

◀ **4** A wide variety of materials can be photocopied to become fascinating collage fragments. Here you can see a piece of an old sweater next to its photocopy facsimile, which was cut and torn and placed in position on the artwork. This will now be photocopied again, with both the photocopy and the artwork collage becoming finished pieces in their own right.

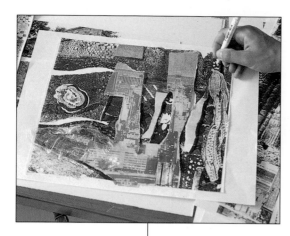

▲ **5** A typewriter correction pen is used to touch in areas of white to the artwork collage. The layers of the collage can be clearly seen here, with the woolly sweater texture alongside the newspaper photograph. Both have been glued on top of the original photocopy.

▶ **6** White oil pastel has also been used to add a lighter passage to the collage, and this is now scored with scissors in the sgraffito method shown in Chapter 2. The colour and texture of the pastel differs from that of the photocopy, adding another dimension to the image.

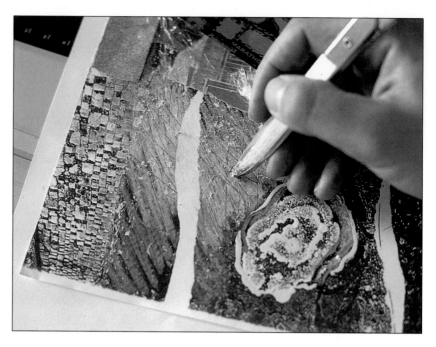

▶ **7** A sheet of acetate was placed over the photographic collage from Project 14, and this was drawn on with a black felt pen. The resulting design is to be placed over the new artwork, creating a kind of "sandwich" of visual information.

◀ **8** In this arrangement of the materials used in this project the two versions of the black and white photocopy can be seen, one with acetate (far right), and one without. The latter is also shown opposite. The final stage was a re-working of the artwork collage in colour, providing two separate versions of the picture.

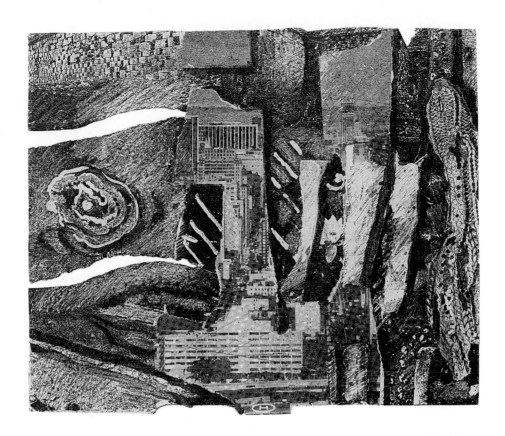

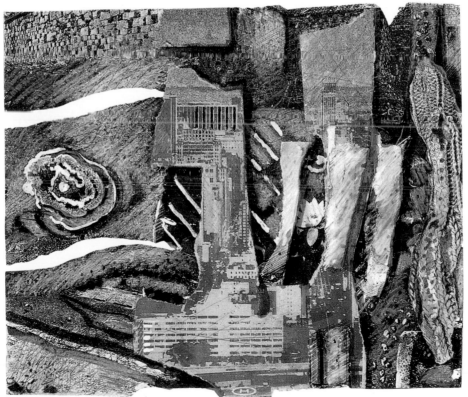

Flakes of History
David Ferry
(Top) Photocopied version
41.9×29.8cm (16½×11¾in)

Flakes of History
David Ferry
(Above) Colour artwork
version
41.9×29.8cm (16½×11¾in)

FOUR-COLOR COLLAGE

*David Ferry uses a dye-transfer method with colored
photocopies to create a sophisticated image.*

Wall of Stone
30.5×22.9cm (12×9in)

This project explores an aspect of the standard photocopier that not everyone is familiar with, namely its ability to make colour copies from a black and white original. Initially this may seem an impossible proposition, but in fact many of the new black and white machines can house single-colour cartridges as well as black ones, so the same image can be produced in several colours. The assistant in a print shop will be able to tell you how many colours are available, and will also load the cartridges for you.

Having made copies of the same image in four colours, I have then cut and torn them in various ways and printed one over another to produce a crude (in technical terms) but effective colour print. This process is very much like the fine-art and commercial printer's system of colour separations, which builds up an image by printing separate base plates one on top of another.

But the beauty of this "kitchen-table" version is that no equipment is needed, not even a printing press. To transfer the colour from the original photostats to the drawing paper I have used the dye transfer method explored more fully in the following chapter. This involves laying the

photostat face down on the drawing paper and covering the back with a solution that releases the ink. The solution in this case was Screenwash, sold for silkscreen printing, but cellulose thinners (acetate) will serve the same purpose and is more readily available.

▲ **1** The starting point was a standard colour print, from which I made a black and white enlargement on the photocopier. This formed the basis for four further enlargements to A4 size. The four colours were achieved by using different-coloured cartridges

▼ **2** I was now ready to take the picture further, so I went back to the original material I had gathered on location – the photograph and my sketchbook, in which I had made comprehensive visual notes.

◄ **3** As this project is a form of four-colour printing the next step was some system of registration. A simple method of marking the corners with masking tape ensured that each colour was printed in its correct position.

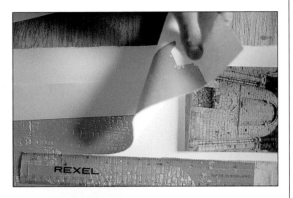

◄ **4** I intended to print the, green first with areas of the other colours showing through, so I have torn and cut shapes in the image. These were not random, but were arrived at after looking again at my original sketches.

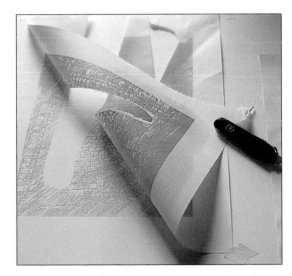

◄ **5** Here you can see the way the torn "negative" shapes relate to the subject.

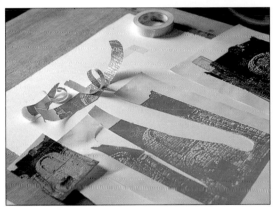

▲ **6** This is the first stage of printing. I have applied Screenwash with a cotton-wool ball to release the colour from the photostat and transfer it to the printing paper (cellulose thinners will serve the same purpose).

► **7** The pressure of the knife handle gives a linear or scribbled mark rather like a coloured pencil drawing.

► **8** I now gouge out a piece from the blue copy and hold it over the green to assess the impression of the two colours. Although the printed image will be reversed, this gives me an idea of the areas of green showing through the blue.

▼ **10** Red was the third colour to be printed. I have restricted this to a smaller area, in keeping with the original subject, where the red brickwork played a lesser part than the grey stone.

◄ **9** The second printing was made in the same way as the first. The marks of the burnishing tool can now be seen clearly.

► **11** The black was left until last because, being the darkest colour, it gives the greatest detail. The earlier colours were a backdrop for the crisp definition provided by the black.

▼ **13** A "still life" of the equipment used for this project. Notice the torn paper, which gives an interesting and lively effect and can be contrasted with cut edges.

◄ **12** As before, I have cut out the areas I did not wish to print, and then applied the Screenwash. This makes the paper transparent so that you can see exactly what you are doing.

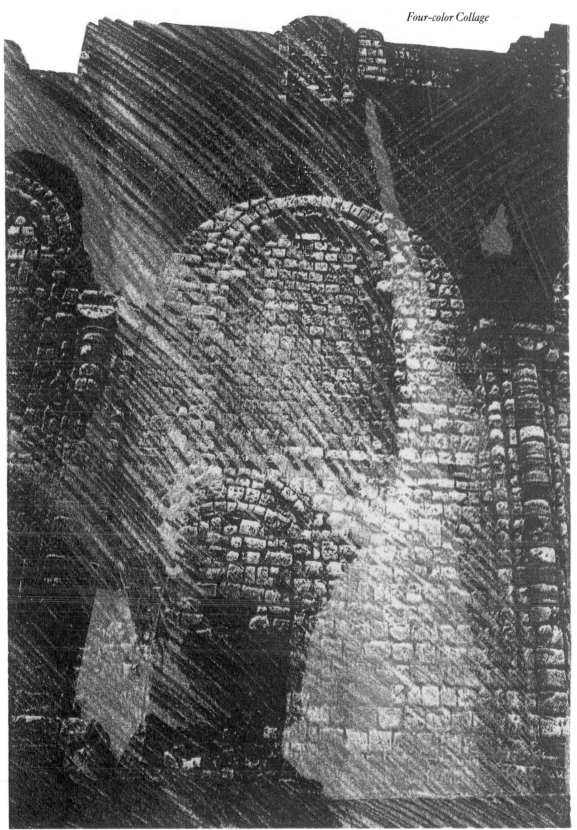

Wall of Stone
David Ferry
30.5×22.9cm (12×9in)

COLOR COPIER COLLAGE

Color copiers can open up a range of new possibilities. David Ferry provides some ideas.

Bridlington Boats
29.2×21cm (11½×8¼in)

One of the many impressive functions of the laser copier is its ability to produce an enlarged full-colour image from a slide. This is a bonus for the artist who prefers to use colour reversal (slide) film but wishes to employ collage techniques to extend the original visual information.

In this project I have used a number of such techniques, beginning on the slides themselves by cutting one in half and placing it over another. This may sound extreme, but on any roll of film there are always a few poor-quality or badly composed photographs, and these are ideal for activities of this kind.

I then put the fragments of slide back together in the mount and used coloured drawing ink to enhance the original colours. These inks are transparent, and therefore do not prevent light shining through when projected or copied in the colour copier. Inks can be applied with a cotton bud or very fine brush, but you could use a fine felt-tipped pen instead if preferred.

The next step was to make a printed copy. A colour print can be reduced, enlarged or made in negative, but in the case I chose a "straight" copy to show the effect of a collaged slide (see opposite page).

For the second example also shown opposite, I took the process one step further by reworking the colour copy, collaging, drawing and painting on it to produce a piece of "artwork" which I then recopied.

Materials & Equipment

35mm slides, colour copies
Fine brush, cotton buds
Coloured inks
Scissors, craft knife
Sandpaper

▲ **1** In this display of the main "ingredients" used in this project the colour slide can be seen alongside some colour laser copies. Basically the project is a simple collage exploiting the two main functions of the colour photocopier: that of producing an image from flat copy and that of producing a flat copy from a transparency (slide).

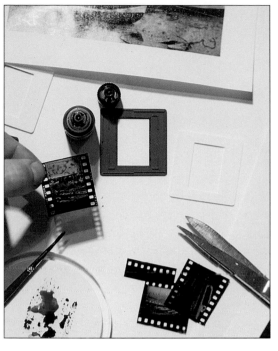

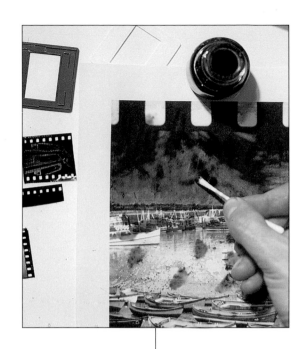

▶ **3** Now I am repainting the colour copy itself (this technique is similar to that shown in Project 19). A cotton bud is very useful in this case, as I want to establish soft areas of new colour over the colour copy. Once finished, this reworked colour copy can act as the "artwork" for a new copy, thus continuing the cycle of constant reworking.

▲ **2** This photograph shows the slide being painted over with a fine sable brush and transparent coloured ink. This is a good medium to use as it is not dissimilar to photographic tones, and will thus allow light through. The prepared slide can now be colour copied to produce a "hard" copy, which will display all the ink reworking on the slide.

◀ **4** Another variation is to collage the original slide with fragments of other slides. Once rehoused in the plastic slide mount, the fragments will hold together well enough for a further colour copy to be made.

◀ **5** The colour copy of the slide now receives further collage treatment. I have used a piece of sandpaper as one of the elements to add a further textural dimension, and am now scoring with a craft knife to make a different kind of texture.

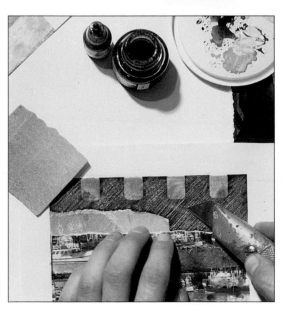

▶ **6** The beauty of this kind of picturemaking is that several "finished" images can result from the same process. This, the "straight" colour photocopy of the collaged and painted slide, is one, and the picture shown opposite, the re-collaged colour print, is another.

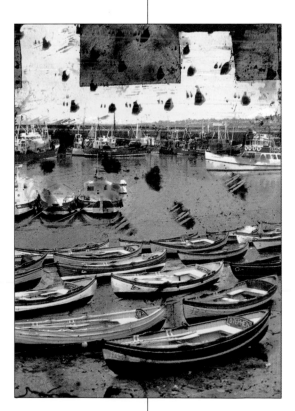

PROJECT 18

PHOTOCOPY ENLARGEMENT

Timothy Emlyn Jones exploits the photocopier enlargement facility to "translate" an earlier work.

*Centre of Stillness –
Flight of Silence*
Composed of 32 A3
sheets

The previous projects showed something of the copier's ability to produce marvellous textures and other exciting visual material. Here it is restricted to its basic function, that of copying, but the project demonstrates the way even a so-called copy can actually constitute a different version of the image. As a basis for this "re-translation" of the subject matter the artist has used a photographic reproduction of his large-scale ink drawing (Project 6).

This was progressively enlarged on the black and white photocopier. Using the enlarging facility allows you to break down an image into sections, each one of which can be enlarged on its own, then resectioned and enlarged again – and so on as often as you like. The end result is a remarkable new view of the original material, and one which is totally in the language of the machine, as the textures produced in this way are quite unlike anything that can be achieved by conventional drawing methods.

The drawing used here serves to illustrate the process, but more or less any piece of visual material can be the starting point for a similar process. Photographs, writing, pieces of textured or patterned fabric, natural objects, indeed anything that is capable of being copied, can be blown up to remarkable scales, and the results, although sometimes surprising, will certainly be intriguing and visually stimulating.

Materials & Equipment

Original drawing

32 sheets normal photocopying paper, A3 size

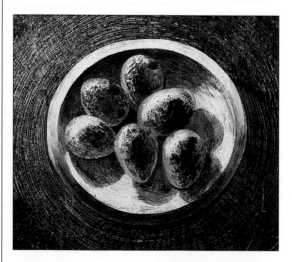

▲ **1** This is the original photograph of the drawing shown in Project 6 on pages 34-37. The massive "photocopier work" shown on these pages was constructed from this image alone.

▲ **2** This single sheet fragment shows the extraordinary way in which progressive enlargements on the photocopier can change the original image. This unique quality can be exploited in many ways.

▲ **3** In order to achieve the heavily textured enlargement he wanted, the artist began by reducing the image, and then enlarged from the reduction.

▶ **4** After several stages of photocopying the artist now pieces together 32 sheets of A3-size photocopy images. Although the subject matter is still recognizable from the original photograph it is very different in quality, with all the mid-toned greys removed.

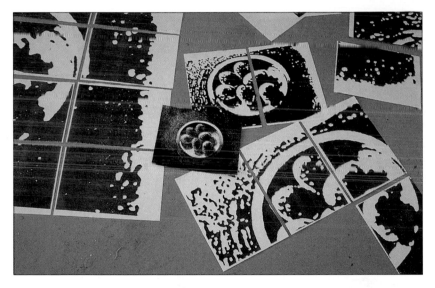

◀ **5** Composite enlargements do not necessarily have to be put back together in the "correct" order. Many different permutations and variations can be tried out.

▶ **6** A work as large as this obviously requires a good deal of wall space, but a smaller-scale version could be made by starting with one area of a photograph or drawing. Alternatively you could enlarge from something quite tiny, such as a postage stamp.

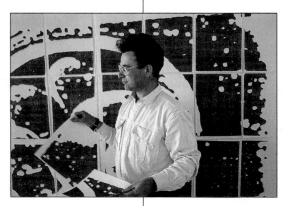

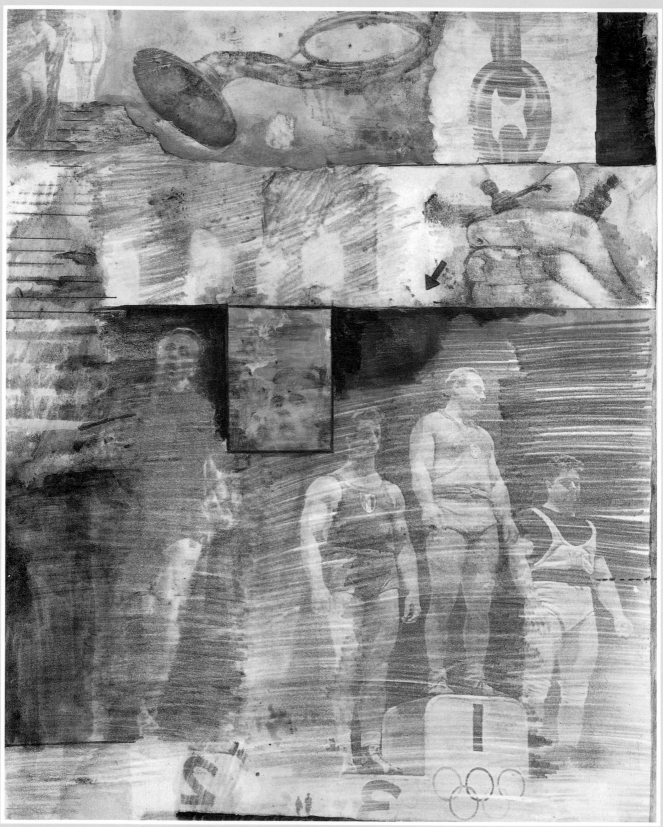

The Central Pit of Malebolge,
the Giants
Robert Rauschenberg
1959/60

Chapter
5

FROM COLLAGE
TO PRINTMAKING

A Moment of Time
David Ferry
1984

Experiments with reworked photographs and photocopies can lead into the realm of printmaking.

Previous pages (left)
The image shown (Canto XXXI from *Illustrations to Dante's Inferno*), is one of thirty-four produced by Rauschenberg making use of a dye transfer method – a remarkable technical innovation at the time. Printed images were transferred to the drawing paper by moistening with lighter fuel (which releases the ink) and scraping with a pencil.

Previous pages (right)
A transfer drawing made entirely with magazine images, with the addition of spray paint and watercolour.

The Promenade, Torquay
Early 20th-century picture postcard

Many modern artists have "taken off" from the practice of hand colouring photographs, common in the era of black and white photography.

I n this chapter we look at some further experiments with what is basically a machine method, in this case the photographic print. Once again I must stress that no photographic expertise is needed; the idea is to take an existing print and work on it to produce a new, or enhanced image.

It could be claimed that to add anything to a photograph would simply devalue it, but one of the most basic processes of art is the constant re-evaluation and reassessment of an initial visual stimulus, so in this context it is clearly a step forwards, not backwards. A standard-sized print just back from the developing and printing service may be entirely satisfactory as a reminder of a holiday or as a personal record for the album, but before it can justifiably be called a piece of art it may require further treatment. The word art is the important one here – we are not concerned with reworking simply for the sake of it, but with creating something more meaningful.

The first project shows a very interesting use of the reworked photograph, which is first painted and then rephotographed. The new photograph is the final image, while the reworking or painting is the intermediate stage. This provides a link with the printmaking chapters that follow, since the painted photograph acts as a kind of block or plate from which an "impression" is made – in this case the final photograph.

The second project, which illustrates a process known as dye transfer, takes us further into the realm of printmaking. The method is a simple one in which solvent is applied to the back of a printed image to release the ink, thus allowing the visual information to be transferred onto a piece of drawing paper. The textures, images, areas of light and dark and so on become part of the paper itself, forming a sort of underpainting which can be elaborated by further work.

Not all images can be transferred in this way; those most suitable are colour magazines (non-glossy) and photocopies. The artistic applications of the photocopier were explored in the previous chapter, but now we can see that the story did not end there – the dye transfer method provides a way of extending the range of possibilities opened up by the "xerograph".

SOME HISTORICAL PRECEDENTS

Because the processes discussed here are essentially experimental, there is little if any literature about them as methods of picturemaking. This is not to say, however, that they have never been used before. The contemporary American artist Robert Rauschenberg produced a major series of drawings in 1959-60, inspired by Dante's *Inferno*. These were made by transferring printed images from magazines onto paper by moistening the backs with lighter fuel to loosen the ink. The printed image was then laid face down on the paper and a pencil was used to apply pressure in

The Rome Notebook
David Ferry 1989

Three standard-sized colour prints were placed next to each other, and coloured inks were then painted on top of them (above). This softened the photographic emulsion, which could then be scraped through to form the crisp white lines that add a textural dimension to the picture.

certain areas so that the result looks both drawn (the pencil marks) and collaged.

Another landmark of collage, which can be seen as related to dye transfer – though less obviously – is Max Ernst's series of frottages (rubbings) called *Histoire Naturelle*. Although technically these have more in common with rubbings proper, the idea of finding the components of a work of art in objects that do not in themselves suggest a painting is central to all forms of collage and its "tributaries".

The painted photograph has deeper historical roots. Before the invention of photography, the "picture postcard" existed in the form of prints (usually engravings), which were coloured by hand. This process continued into the age of the camera, with the early black and white prints, both views and portraits, often being "coloured in" for wider appeal.

This practice has also had some influence on modern artists, notably Andy Warhol, many of whose canvases are a blend of photography, painting and printmaking. The photographic element in these pictures has a curious "double take" effect, causing us to question our perceptions regarding reality and illusion.

PROJECT 19

A PAINTED PHOTOGRAPH

Michael Sheedy has produced an unusual self-portrait by combining photography and painting.

The Exile
25.4×20.3cm (10×8in)

Although colour print film is the most widely used by amateur photographers, black and white film stock can still be purchased and printed. Because this project is based on the colouring and painting of the photograph, the artist has begun with black and white. He has also used a tripod, as he wanted to produce a blurring effect by photographing at very low speeds. This need not be a major factor in every case, however, as it is perfectly possible to produce interesting results with the most basic of photographic equipment.

In many ways the camera can parallel the stages in collage manipulation and fast-process printmaking, because variations on different themes can be produced by changing the aperture, the speed or simply the angle from which the picture is taken. This gives the artist a large range of possibilities, which can be displayed together very much like the David Hockney photographic collage on page 11. Here the artist began in this way and then considered which image he should take further by introducing colour and texture.

For the painting stage, he used two basic materials and a wide range of implements, including Q-tips and soft rags. The colouring media were felt-tipped pens – markers can also be used – and water-soluble coloured drawing inks, both of which provide a rich kaleidoscope of colours and tones, and "sit" well on the photographic paper.

The result of the colouring process is an intriguing cross between painting and photography. It can simply be left as a picture in its own right, but in this case the artist chose to take the image a stage further by rephotographing on colour reversal film (slide film) and then having an enlarged colour print made of the slide. This hybrid could itself be reworked, beginning the whole process again, and there is no reason why the laser printer, or colour copier, explained in the previous chapter, should not be brought into play also.

Materials & Equipment

Sketchbook

Camera, tripod

Black and white film

Felt pens, markers, coloured drawing inks

Cotton buds, rags

Scalpel

▶ **1** Although this is basically a photographic project, initial edits or schemes can best be planned out from working drawings, as shown here. These help the artist to select the most interesting and visually appropriate idea to translate into the chosen medium.

▲ **2** This is a kind of self-portrait, with the artist himself forming the central motif. With the camera mounted on a tripod he photographed himself using the shutter-delay mechanism, a device found on many cameras.

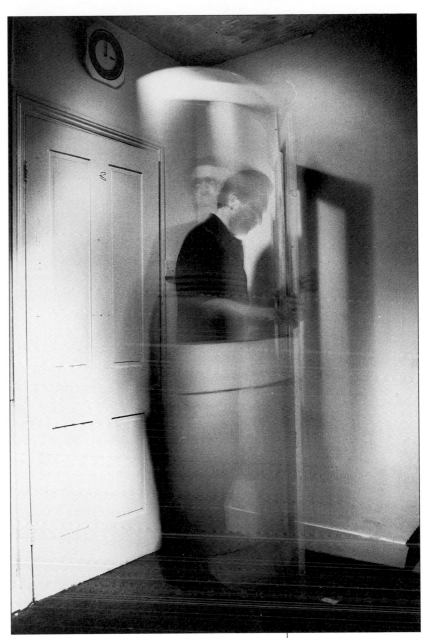

▶ **3** A particular feature of the resulting photograph is the "ghost" image caused by using a very slow shutter speed. The effect is far more dynamic and exciting than a straightforward "frozen motion" shot.

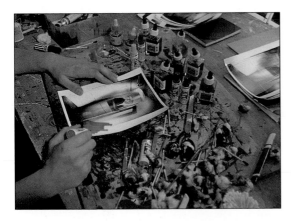

▲ **4** The artist now works on the photograph with a variety of markers and coloured inks, which create marvellous effects on photographic paper.

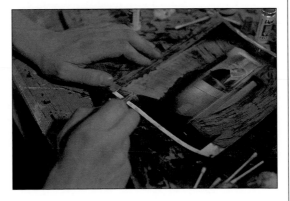

◀ **5** This photograph shows a scalpel being used to incise lines in the photographic paper. Colouring with the felt pens had the effect of softening the surface of the paper, making this scratching through quite easy. Transparent coloured ink can then be added over this "etched" base to reinforce the image without obscuring either the photograph or the later work.

PROJECT 20

DYE TRANSFER

Here David Ferry has combined dye transfer with photocopies of a variety of objects and textures.

Box Display
99×69.9cm (39×27½in)

Materials & Equipment

Cardboard for box unit

Starfish and other objects

Screenwash solution

Scissors

Cotton wool

Small hand roller

Good quality drawing paper (smooth)

Drawing board

Rags, brushes

Coloured inks, coloured pencils

Here I have returned to the photocopier, and in this case have used it to reconstruct a three-dimensional structure, namely a home-made cardboard display unit. I began by taking this apart, that is, opening it out, so that it could be placed flat on the glass slab of the copier. I then placed a selection of other objects on the slab and, after photocopying each in turn, was left with a series of fragments of the original, which I then collaged back together to form a two-dimensional concept of the solid object. I have mainly used the A3 paper size in preference to the smaller A4.

The collage aspect was achieved by the dye transfer process explained in the introduction to this chapter. By applying solvent to the back of the photostats, the images can be quickly transferred to drawing paper to serve as the basis for further drawing or painting.

This is a flexible method, as a great deal of quite complex visual material can be put onto the paper as a preliminary stage, allowing the artist to try out various different permutations of the subject in advance. Being limited to only one compositional form can inhibit experiment, and there is also the fear of destroying a composition that has taken a long time to produce by trying too many variations. This method allows you to test more or less infinite rearrangements, because there is nothing much to spoil. You are only using photostats, not expensive photographic enlargements or time-consuming drawings, and photostats can easily be done again. Dye transfer need not be confined to photostats. You can also use colour images from

magazines or newspapers – the fresher the better, as the ink will still be quite tacky. Reproductions on glossy paper, however, cannot be transferred, and neither can photographs.

Although the principle is the same for both colour and black and white images, the solvents are different. The one used for this project was Screenwash (sometimes called general-purpose cleaner), which is sold for silkscreen work and available from specialist suppliers (see page 132). This is the most suitable for photocopies, but is too strong for the commercial printing inks used for magazines and newspapers – it breaks up the ink and blurs or destroys the images. Solvents for these include white spirit, lighter fuel and decorator's brush-cleaner. When using either the latter or Screenwash, make sure to adhere to warnings and instructions, as contact with skin or eyes can be dangerous.

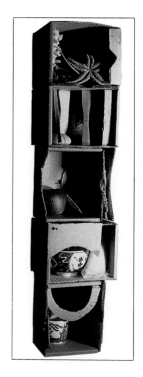

▶ **1** This is the original three-dimensional object with which the project began. It is nothing more than a simply made display unit housing a collection of different objects, chosen in this case for their colour relationships and variety of textures.

◄ 2 Removing the objects from the box, I placed them on the glass of a black and white photocopier and then made a number of photostats showing different arrangements.

► 3 I then took the box apart and made copies of this in the same way. These copies will play an important part in creating a two-dimensional version of the original three-dimensional form.

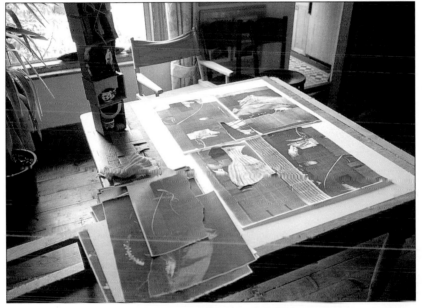

► 4 Here the box unit and the photocopies can be seen together. The next stage is the dye transfer, and I have already begun to arrange the A3 photocopies preparatory to transferring the images onto drawing paper. I shall not do this, however, until I am satisfied with this first part of the composition.

▼ 6 The Screenwash makes the ink slightly sticky, and I use a hand roller to ensure that both layers of paper adhere to one another while I work. I then score the back of the photocopy, which releases more ink and produces linear marks on the drawing paper

► 5 Now I am carrying out the dye transfer. The bottle cap holds Screenwash solution, which I soak up with a cotton-wool ball and apply to the back of the chosen photocopies. An even spread is needed to loosen the ink and release it onto the drawing paper.

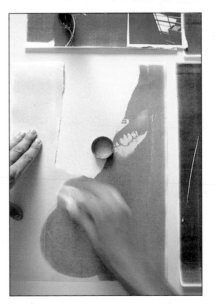

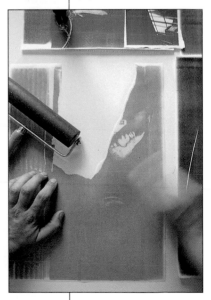

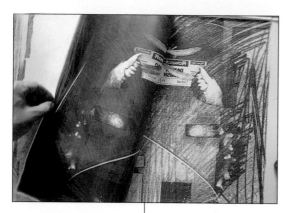

▲ 7 I am now removing the photocopy to reveal both the "print" and the drawn marks produced by the scoring action. Like any printing method, dye transfer produces a reversed image, so any written information on the photocopy will come out backwards. The legibility of the words were not a factor in this composition, so this did not worry me.

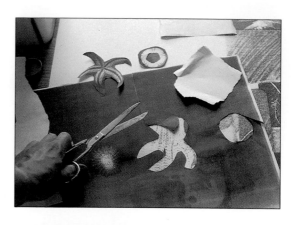

▶ 8 My next step was to cut specific shapes out of the original photocopy. The starfish seen here was a photocopied version of the real object first seen in the box display on page 88. The photocopy reproduces a curious "reality" of its own, which I find particularly interesting.

◀ 9 This is a detail of the cut-out dye transferred shapes in position on the drawing paper. The next photograph shows these in the context of the whole composition.

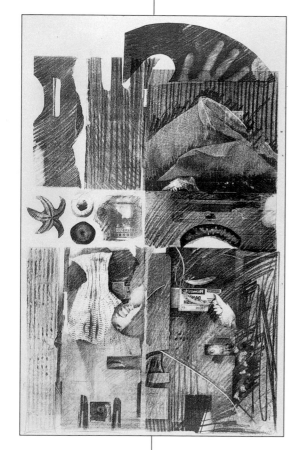

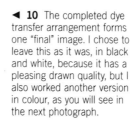

◀ 10 The completed dye transfer arrangement forms one "final" image. I chose to leave this as it was, in black and white, because it has a pleasing drawn quality, but I also worked another version in colour, as you will see in the next photograph.

▼ 11 I have applied colour to this second version in a number of different ways. Coloured drawing ink is particularly suitable for dye transfer as it is transparent and will not hide the detail beneath. I laid this on with rags and brushes, using a spattering method in places, and finally added linear touches with coloured pencils.

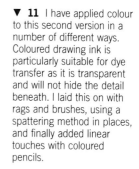

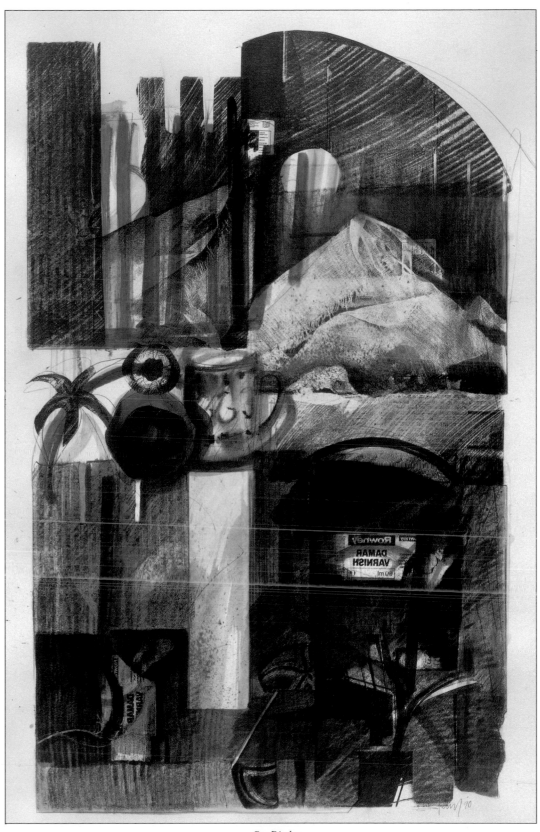

Box Display
David Ferry
99×69.9cm (39×27½in)

The Bidet
Edgar Degas
c.1880

Chapter

6

THE MONOPRINT

Still Life with Bottle
Steven Kent
1989

The monoprint is a simple process which can produce sophisticated results with the minimum of equipment.

In the final chapters we will look at some simple but inventive methods of making pictures by various printing methods. People are sometimes put off the idea of printmaking because they think it is highly technical and complex. It can indeed be so, but it can also be very direct and basic, the obvious example being the potato cuts that many young children do in school. A kind of printmaking can even be seen on the painted walls of certain prehistoric caves, where hands were used as a mask and painted around and through, in a crude version of the stencilling technique.

It is my intention here to promote a way of working that allows for a wide range of artistic expression while making use of only the most rudimentary equipment. Familiarity with the basic process will open up a whole world of exciting prospects, and the idea of the interconnection between media explored throughout the book can be given even further licence to expand.

THE STARTING POINT

In the context of printmaking, the monoprint (sometimes called monotype) forms a natural beginning. It is a classic example of a simple process which can produce sophisticated and highly varied results with no equipment except that which the painter has anyway. Oil or acrylic paints can be used instead of printing ink and the only other requirements are a cleanable surface such as a piece of glass or formica.

The monoprint is a "one off" process, and it is

Peat Barrow and Figure
Barbara Rae 1988

Rae's sophisticated multi-
coloured monoprint (right)
aptly demonstrates the
possibilities of this most
simple of all printing
methods. The artist explores
her ideas through
imaginative use of a number
of techniques; she also
works extensively in collage.

Desert Adventure
Katie Lester 1988

Lester's figures are very
simple monochromatic
monoprints which are then
cut out and mounted on
balsa wood. she uses them
in a variety of different ways
to "act out" scenes and
dramas; this witty image of
travel in a bygone era has
been achieved by arranging
all the separate elements in
sand. As can be seen from
the individual images, very
subtle draughtsmanship and
varied textures can be
obtained through the
monoprint process.

this which gives it its name (mono – one). The principle is that an image or design is painted on the piece of glass or other surface, the paper is placed on top, pressure is applied by hand – and you have your print. A variation on this, and one which is shown in the first project, is to lay a flat colour all over the glass, place the paper on top as before, but this time apply pressure only to certain areas by drawing on the back of it. As long as the ink is not too wet, only the drawn lines will print.

The idea is usually credited to a 17th-century Italian painter and etcher, Giovanni Benedetto Castiglione (called El Grechetto), who developed it in Rome in 1635. A century and a half later the English visionary painter William Blake used certain monoprint methods in his work, which were often painted over as well.

From the 19th century onwards artists began to take an interest in the printmaking process itself; hitherto it had been mainly the province of specialist assistants, or "printers", whose job it was to make a facsimile of the artists' work on a block or plate. The change in attitude inevitably resulted in a rediscovery of the monoprint, and it

was marvellously exploited by Degas, an innovative and endlessly enquiring artist who was fascinated by all branches of printmaking. Although theoretically only one print can be taken from the painted or inked plate, he used an engraver's press which, because it produced a stronger image, enabled him to take two or three.

Earlier in this century the monoprint process was introduced into the curriculum of the Bauhaus in Germany (the school of architecture and design founded in 1919, which became the centre of modern design). This is significant, since the Modernist movement, as it was called, was concerned with an investigation of image and the generation of image, and thus the monoprint as a creative process gained in stature. Paul Klee, Henri Matisse, Georges Roualt and Marc Chagall all used it, as do many of today's leading artists.

When reading a printmaking magazine recently I found the word joy used in connection with the monoprint. If I were to add the words spontaneity, freshness and freedom, I might hope to convey at least a flavour of what this activity has to offer.

GLASS-SLAB MONOPRINT

The versatility of the rolled-slab monoprint technique is beautifully exploited here by David Ferry.

Realigned Forms
71.1×53.3 (28×21in)

Materials & Equipment

Glass slab

Oil-based printing ink

White spirit (for cleaning)

Cartridge paper (for masks)

Printing paper

Masking tape

Hand roller, palette knife

Combs, screwdriver, pencils, ruler

In some of the earlier projects we have come fairly close to the language of printmaking. Two obvious examples are the dye transfer and photocopy projects, but the painted collage (Project 11) and the frottage method featured in Project 2 also have a relationship with print procedures.

This is rolled-surface monoprint, that is, I have inked the whole surface of the glass before placing the printing paper on top. Although I have used printing inks of the type used for lino cuts, oil paint is equally successful. The design is achieved by selective pressure applied to the back of the paper in the form of pencil lines, a process related to Rauschenberg's dye transfer method mentioned on page 82.

The pencil is one of the most satisfactory implements for this process, not only because it produces a fine, crisp line but also because you can see what you are doing. However, there is always an element of surprise and this is one of the most exciting aspects of the method. As you can see from the photographs, the simple pencil marks take a quite different form on the print itself.

Other pieces of equipment can also do interesting things. A comb, for example, makes marvellous continuous lines of tone or texture; a screwdriver can produce thick and thin lines depending on how it is held; and your hand can be the most sensitive of all mark-making tools, producing areas of both tone and texture. But beware of allowing your hand to rest on the paper accidentally, as it will immediately produce a mark, which may be the reverse of what you had planned.

You will quickly begin to appreciate the remarkable flexibility of this version of the monoprint, and see how widely the marks made can vary while still fulfilling the basic function of pressure. Even as a monochrome technique, it can be an exciting and challenging method.

In order to demonstrate its full capabilities, however, our example has three colours – two blacks and one red – each printed as a separate operation. Printing ink dries very quickly, which makes it possible to print more than one colour in a day, indeed this was done in a single working session.

Oil paint dries slowly, so if you are using oils it is advisable to print the first stage of several different images in one working session, leave them to dry and proceed with the second colour on another day. For further variations you could then make first prints from the second colour, and so on, to continue the cycle. It is always a good idea to make alternatives and other versions in any case, as these may be better than the first attempt.

The printmaking process can be combined with masks or stencils to inhibit the passage of the ink or paint onto the paper in certain areas, and further drawing can be printed on a subsequent session. Nothing need be wasted at any stage: unsuccessful attempts can be cut up and used for collage, while others can form a foundation (when dry) for another drawing or painting. They could then be photocopied and dye transferred, as explained in Project 15 – the beauty of the mixed-media approach is that more or less anything is possible.

▶ **1** The materials required for this project are not at all elaborate; basically all that is needed is a glass slab, a small roller, ink or oil paint and an initial design or working drawing.

▼ **2** In this version of the monoprint technique the whole surface of the glass slab is inked up by "feeding" the roller with a palette knife and then rolling it over the slab to produce an even but not too thick layer of ink.

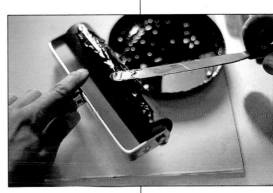

◀ **3** A sheet of paper is now placed over the inked slab preparatory to drawing. Any pressure applied to the paper – for example by pencil drawing – on the top will result in a printed mark. Masks have been placed around the edges of the inked slab to give a straight, clean edge to the print

◀ **4** In this case I have decided to use masks on the surface of the inked slab also. These were made simply by drawing a basic design on a sheet of cartridge paper and cutting it out. The "positive" and "negative" motif provide an interesting background to the monoprint when printed with simple hand and comb pressure

▼ **5** The printing paper is now lifted off the slab, with the masks still in place on the glass. As you can see, it is only the unmasked areas that make the printed image. The linear hatching effect was produced by dragging a comb over the top of the printing paper.

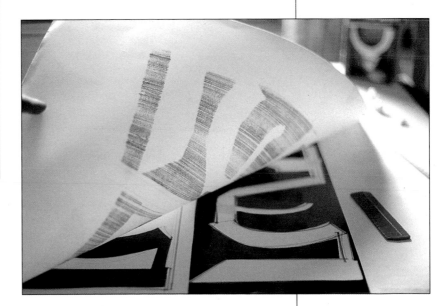

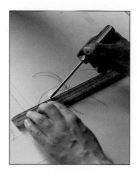

▲ **6** The print has now been replaced on the slab for a second printing, and I am "drawing" with a small screwdriver to produce specific images. I have made a masking tape hinge across the top edge of the paper so that it can be brought down each time in the correct position.

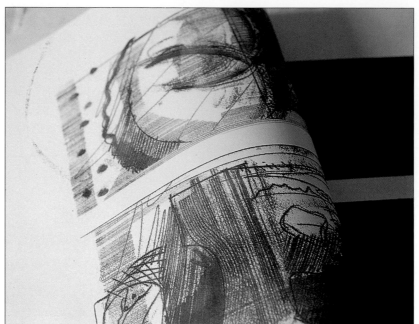

◄ **7** This photograph shows the result of the new printing. The screwdriver drawing has produced a wonderfully rich line, with a quality unique to the monoprint technique. It has both the definition of print and the sensitivity of a conventional drawn line.

◄ **8** A further stage of "drawing" through the printing paper. I have used a pencil as well as the screwdriver, since pencils give a softer line, and the contrast helps to produce a rich and varied final print. Another advantage, of course, is that you can see the marks you are making, whereas the screwdriver is a "blind" drawing implement.

▼ **10** Here the hinge system can be seen clearly. The edge of the glass slab is away from the paper's top edge, which allows the print to be pulled over and away from the slab for viewing.

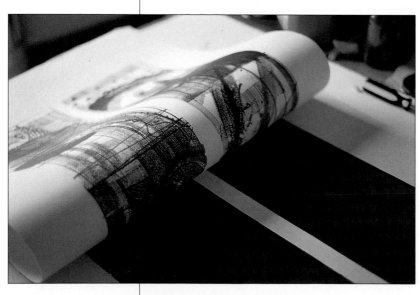

▲ **9** A new colour adds a further dimension to the image. The masking tape registration system enables several stages of overprinting

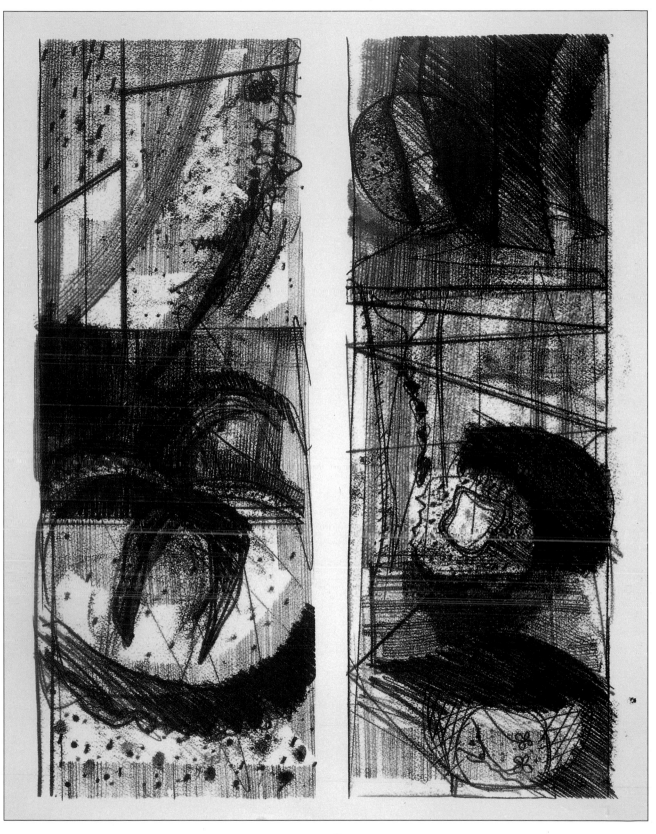

Realigned Forms
David Ferry
71.1×53.3cm (28×21in)

PAINTED-SURFACE MONOPRINT

As Katie Lester shows, the monoprint technique is the perfect "kitchen table" printmaking method.

Stars and Waves
38.1×55.9cm (15×22in)

Materials & Equipment

Glass slab

Oil-based printing inks

Mixing bowl (for ink)

Cardboard scraping tool

Brushes, white spirit, rags

Newsprint-type paper (for printing)

Thin cartridge paper (for stencils)

This is perhaps the best-known version of the monoprint process, and has more in common with traditional printing in that the design is formed on the glass slab, which acts as a plate or block.

There are many advantages to this method, the first being that the artist can explore many variations of design, colour and texture before committing anything to printing paper. It is also a much quicker and more spontaneous process than either conventional painting or printing techniques, as prints can be taken from several different stages of the painting before the image is finalized. These "working out" prints can then be looked at together as a group, very much like preliminary sketches or other visual information, allowing the artist to judge whether one or more forms the basis of a successful picture. As will be seen, the idea of having more than one version of a particular composition is important in the context of displaying the finished prints.

The ink or paint can be applied to the slab in whatever way you choose. Any of the painting techniques described earlier are applicable. A diffuser can be used to blow ink onto the surface; it can be dripped or dribbled, drawn into or moved around on the surface with a variety of home-made "combs" fashioned out of pieces of card to produce patterns and directional marks.

The choice of printing paper will also make its contribution to the finished image. A thin, absorbent paper rather similar to newsprint was used here. This has given a very delicate and sensitive print because the ink has been taken up into the fibres of the paper, and it is also fine enough to reproduce the subtleties of texture and tone on the slab. Simple hand pressure was all that was needed to produce the impression.

The various different versions of the subject were made, not only to work out the design but because the artist wanted to make a complete record of the subject, binding the prints together in book form. This series idea is far from a new one; many artists produce work in sets, intending them to be seen in this way rather than as single statements. It would be possible to expand the idea to illustrate a story or provide an individual record of a specific journey or experience, very much in the way that a photograph album can provide a family record for posterity.

▲ **1** A glass slab and paper, plus paints or inks, is all that is required to produce a painted-surface monoprint. The paper under the glass slab, which is the same size as the printing paper, allows the artist to judge the sizes of her images and textures in relation to the glass surface. It also serves as a registration key so that the printing paper can be placed in exactly the right position.

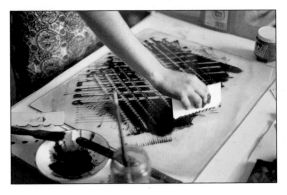

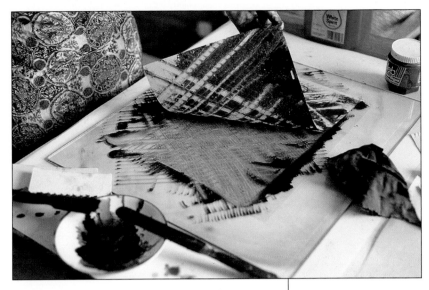

▲ **2** A homemade cardboard "comb" is used to draw into the ink to produce textures. This method of making monotypes is very flexible, and if at this point the artist does not like what she has produced she can simply wipe the slab and begin again.

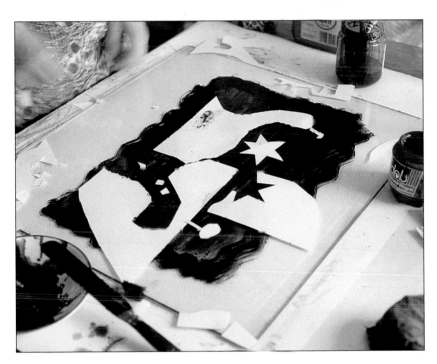

▲ **3** The printing paper is now placed face down on the glass slab to make the first print. Thin, highly absorbent paper has been used in this case so very little pressure was needed. The paper can be pulled away from the slab to review the work, and replaced if the print is too light.

◄ **4** Paper stencils can also be placed on a layer of ink. These act as masks, thus remaining white on the prints, and they can be as intricate or as simple as desired.

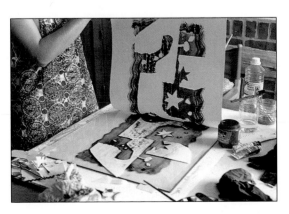

◄ **5** The finished print (see opposite page) is now removed from the slab. Some further uses of Lester's experimental monoprint techniques can be seen on the following pages.

► **6** The stencils themselves have been indirectly printed in the process. These could be reused, perhaps as collage fragments for another picture.

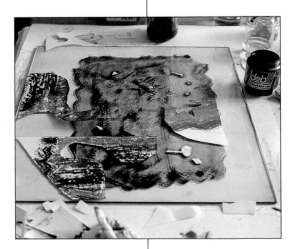

Here we see a selection of images made by the simple monoprint technique demonstrated on the previous pages. The artist has now taken the process one step further to produce complete large-size albums, an imaginative and exciting use of this "kitchen table" printing method. Several images linked in subject matter and collated in this way can often make a fuller statement than one single print or painting, and many artists produce work that is intended to be seen as a series.

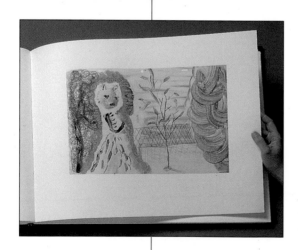

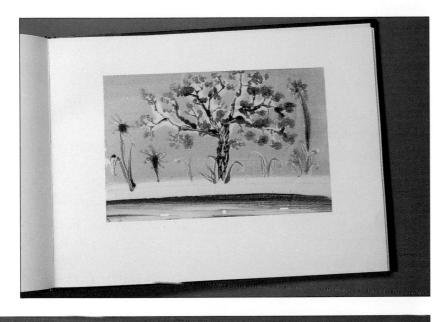

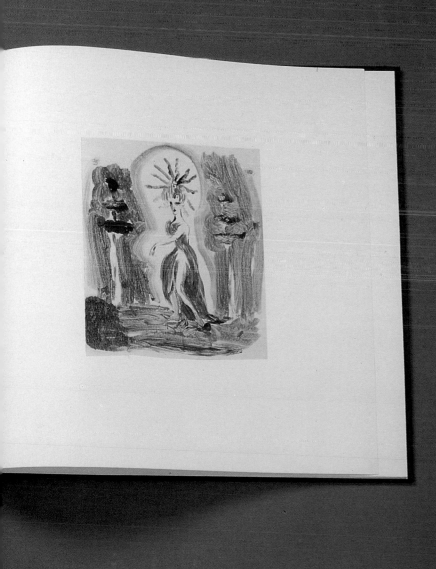

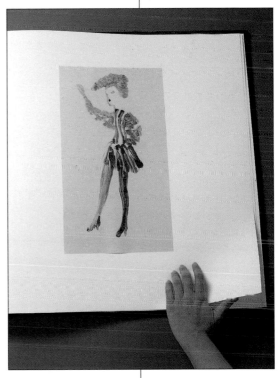

23

MIXED-TECHNIQUE MONOPRINT

To create this sophisticated image, David Ferry has combined both versions of the monoprint method.

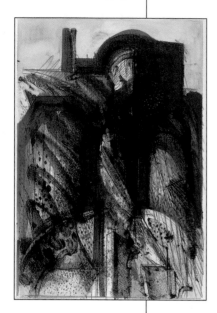

Red Ruined Wall
101.6×74.9cm
(40×29¹/₂in)

Materials & Equipment

Cartridge paper, printing paper (both heavy and lightweight)

Transparent oil-based inks

White spirit, rags

Masking tape

Hand-printing roller

Cotton buds, drawing inks, coloured pencils

Toothbrush, bristle brushes

This is a synthesis of the two methods described in the previous projects. Both of these offer a wide range of possibilities, which is obviously increased when the two are combined. The first technique, that of drawing on paper placed on a pre-inked slab, allows you to achieve exciting variations of line and tone. The method of making the design on the slab itself, essentially the opposite of the first, allows you to create areas of pure colour and texture.

If you make a mental distinction between the two processes you will be able to structure your design in terms of background and foreground, with the flat colour acting as the backcloth to the drawn structure.

This is roughly the way this print was planned, and my first step was to make a very free and gestural base drawing on the slab. More than one colour can be used, but it is important to bear in mind that the inks or paints will mix together, especially if thinned with white spirit, which can result in a muddy mess. This can be avoided by using separate painting tools for each colour. Corrections and alterations can be made as often as you like, simply by wiping away unwanted colour with a clean rag.

Once satisfied with the "background" element of the design I took several prints, using no more than simple hand pressure. At this stage you can experiment with different papers, as variations in the texture and behaviour of the surface will affect the appearance of the print. In general, thick papers are more absorbent than thin ones, but you will have to experiment to find the most suitable surfaces. Smooth cartridge paper is easily flooded, especially if there is a high content of white spirit in the ink.

The second stage introduced the linear element, for which I re-inked the slab with flat colour and proceeded as explained in Project 16. A print can be considered finished at this point, but it can be worked on further, as I have done here, to become a true one-off combination of printing and drawing/painting. Flat colour can be applied directly onto the print with a roller, using simple paper masks to protect areas where it is not wanted. Final touches of over-drawing can be done with coloured pencils, and inks applied with Q-tips or the fingers used for small touches of local colour.

▲ **1** The sketchbook drawing used as the basis for the monoprint was made with markers which, being transparent, have a similar quality to the ink I shall be using. (Printing inks can be either opaque or transparent.) I have placed a sheet of white cartridge paper under a glass slab and then drawn the design on the glass, to act as a guide for applying the ink. The masking tape around the edge marks out the extent of the design.

▲ **2** The white paper below the glass allows me to judge the colours accurately. I am using oil based ink made for relief printing and lithography, which can be diluted with turpentine or white spirit and applied in broad washes. For this stage I use rags, toothbrushes and conventional oil-painting brushes.

▶ **3** With the first painting stage complete I am now ready to take a print. The amount of colour that will be transferred from the inked glass to the paper depends on the type of paper used, the wetness of the ink, and how much pressure is applied. A very gentle hand pressure was used in this case.

◀ **4** After an initial printing the glass slab can be re-drawn and painted. I have applied more intense colour as well as a spattered effect produced by flicking an inked-up toothbrush. Some registration system is needed for a second printing, and here the printing paper is held by masking tape along one edge of the glass slab so that it can be brought back down in the correct place onto the new colour.

▶ **5** The printing paper is now brought back down onto the re-painted slab. The advantage of this systematic way of working is that separate layers can be built up over a period; the print need not be completed in one session.

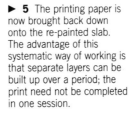

▶ **6** I have now removed the paper from the slab and held it up to a window, which enables me to see through the print while I draw in the main shapes with pencil on the back.This is important because for the next printing I shall use the alternative monoprint technique, that of rolling up the slab in a single colour and drawing on the back of the print (see Project 21).

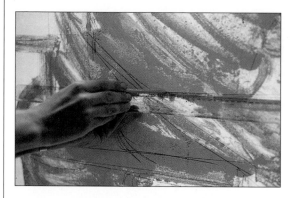

▲ **7** With the print face down on the inked slab, I am scoring and dabbing the back of the paper to produce lines and textures on the print.

▶ **8** The effect of both monoprint techniques can be seen in this detail. The dabbing action shown in the previous photograph has produced the dotted area of texture, while the larger, open areas of colour were the result of the technique of painting on the slab. As before, the printing paper has been secured at one end and therefore can be pulled up to assess the print before reworking.

▼ **10** I now roll colour on top of the unmasked areas of the print. Because of the transparency of the ink, I am in no danger of obscuring any of the earlier drawing. As a final touch, after the print was dry, I drew back into it with coloured pencil and dabs of coloured drawing ink.

▲ **9** I have cut paper masks to shield certain areas of the print preparatory to adding further colour to other parts.

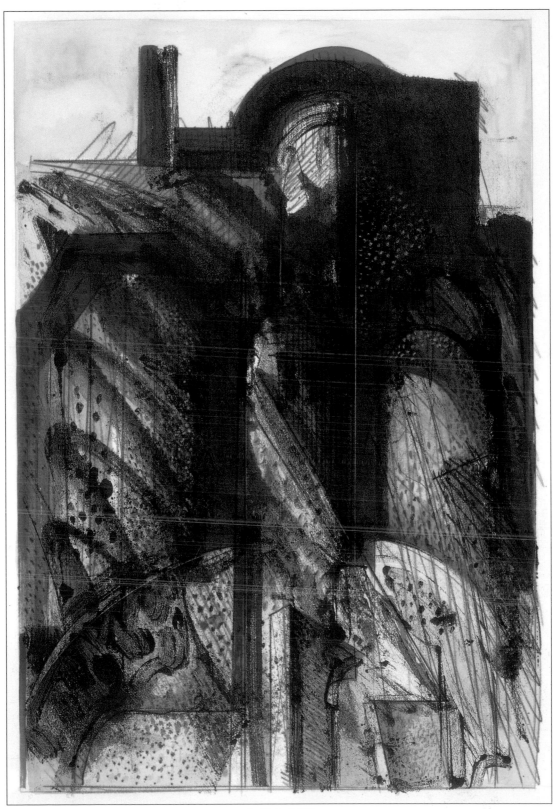

Red Ruined Wall
David Ferry
101.6×74.9cm (40×29½in)

Skat Players, Pacific
Restaurant, Hamburg
Horst Janssen
1962

Chapter
7

THE
BLOCK PRINT

Hollow of the Deep Sea Wave
off Kanagawa
Hokusai
c.1822/9

Almost anything can be used as a printing block — even a piece of discarded packaging with other materials glued onto it.

Previous pages (left)
In Janssen's colour woodcut, unconventionally thick layers of ink have been built up to produce the exceptionally vivid colour.

Previous pages (right)
No chapter on block printing would be complete without an example from Japan, since Japanese prints have been an inspiration to Western artists ever since they were "discovered" in the 19th century. This print, produced from several blocks, is part of a famous series by Hokusai, the thirty-six views of Fuji.

Red Cathedral
David Ferry 1985

A block print made from a single piece of hardboard (right). It was produced by the reduction method, which involves cutting away more of the design for each new colour to be printed. Block prints can be as small or large as desired; this particular example measures 152.4×91.4cm (5×3 feet).

The previous chapter, while introducing the topic of printmaking, treated it mainly as an extension of drawing and painting activities. This one explains the significance of actually constructing a block, which not only extends the concept of "seeing through doing", but also provides an extra dimension, since the block is not just a necessary stage in printmaking but also an object in its own right.

So what is this thing called a block? Most people, not unnaturally, think of a piece of wood or lino into which a design is cut, but although these certainly are blocks, there are a great many other materials that can serve the same function. For example, a sheet of cardboard with other materials glued onto it can be just as viable in this context, although rather less permanent.

In printmaking, the end reflects the process in a particularly direct way, and this enhancement of the image through materials and technique is one of its most basic and appealing qualities. Trying to make a print look like some other form of visual expression would be a fruitless exercise which missed the most important point. What I hope to show here is that simple materials and non-specialist equipment coupled with the desire to investigate pictorial possibilities can produce sophisticated and satisfying results.

FUNDAMENTAL PRINCIPLES
Basically, there are two main categories of block prints, the relief print and the intaglio print. In the former, the parts that are to remain white in the print are cut away, leaving the design standing out from the surface in relief. Intaglio printing is the method used for etching, in which the design is incised into the surface. Before printing the whole plate is covered with ink, which is then wiped down so that the ink remains in the grooves. Here we are mainly concerned with versions of the relief print, as intaglio prints usually require a press, and are thus outside the scope of the book.

A BRIEF SURVEY
The earliest form of relief blocks were the seals found from several ancient cultures, and the Romans also carved into stone to make an equivalent of our present-day rubber stamp. Woodblock prints as we know them today, however, did not appear until the 15th century, after Johannes Gutenberg's invention of the printing press about 1450. Woodcuts were widely used for book illustration, and the technique was brought to amazing heights of technical virtuosity by Albrecht Dürer in the early part of

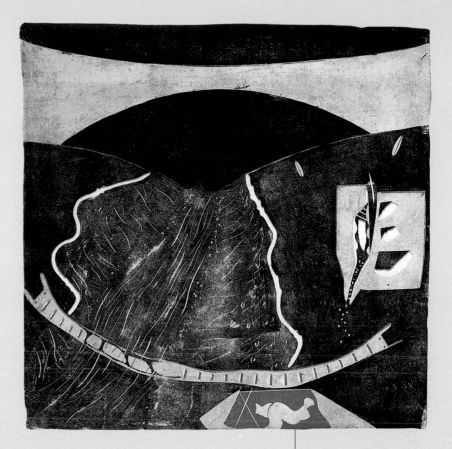

the 16th century. His marvellous draughts-manship gave his work an expressive force that provides the perfect example of the principle of "truth to material".

The woodcut was gradually superseded by metal engraving (intaglio), usually on a copper plate, which was capable of more subtlety and refinement, but towards the end of the 19th century there was a great artistic revival of the woodblock. Paul Gauguin, Edvard Munch and several leading artists of the German Expressionist movement all exploited it.

The linocut did not appear until earlier in this century, with the invention of the material itself. Linoleum was originally used as an inexpensive substitute for wood, but although linocuts are similar to woodcuts in principle, the end products are quite different. Two artists who immediately saw the potential of the linocut were Matisse and Picasso, the latter using the method to produce colour prints. The contemporary British printmaker Michael Rothenstein has also exploited the method in innovative ways, creating tonal and textural effects, and using various cutaway jigsaw-like blocks to construct complex images.

THE COLLOGRAPH

This term needs to be explained, since it is a less precise one than those used for the techniques in the main stream of printmaking. The word collograph (not to be confused with collotype, which is an early form of photography) is in fact the American term for an intaglio wiped-block print. As we have seen, a conventional intaglio block, such as those used for etchings and engravings, cannot be printed by hand, but it is possible to construct a version of the collograph block which can be inked up to give hand impressions. A well-made block can yield both relief prints taken by hand and intaglio prints made by means of a press, and an example of the latter is shown in the collograph project on page 112 simply because it is the next logical step forward in printmaking.

In many ways the collograph is at the forefront of developments in printmaking. Not because it utilizes new technology or methods – indeed the reverse is the case – but because it exercises the artist's ingenuity in constructing a form and then making something else out of it. Because this idea forms a central theme here, I have chosen to place the collograph project first, thus enabling you to discover something of its rich possibilities before moving on to the relief print.

Apart from its ability to produce two separate types of print, one of the most exciting aspects of the collograph is that the block itself can form an artwork in its own right. By using inexpensive materials we free ourselves from accepted notions about traditional or accepted ways of doing things. We are under no obligation to produce a perfect edition of identical prints, which is the main concern of the professional printmaker, but can give our creative impulses free rein to do as they choose. If prints are not successful, perhaps the block will be pleasing as a piece of relief sculpture, and the prints can in any case be used again in the form of collage or as a starting point for a different piece of work.

Block IX
Matthew Hilton 1989

Hilton's large-scale linocuts are printed by hand in very small editions (this is from an edition of only two), as the artist is more interested in the feel of the process than in commercial production. He exploits the process with great skill and sensitivity, and chooses the colour and texture of his printing paper carefully so that they enhance his images.

COLLOGRAPH BLOCK

*Heather Libson bases her hand-made printing blocks on
natural forms.*

Cypher Series
62.9cm (24³/₄in) square

Materials &
Equipment

Cardboard (for base)

*Decorator's filler, acrylic
gel medium*

*Gauze fabric, bristles from
a brush*

*Polyurethane varnish,
brushes, rags, white spirit*

Lino inks (for relief print)

*Etching ink (for intaglio
print)*

*Printing paper in various
colours, textures and
weights*

Although a relatively modern technique, this is an interesting concept which forms a good jumping-off point for the series of projects in this chapter. It also relates to some extent to the collage chapters, in which we explored the idea of the building up and placing of visual materials as an integral part of the creative process.

This project and those that follow, however, depart from the collage in that the former case involved manipulating materials which had an intrinsic visual appeal, while these start more or less from scratch — there is nothing particularly visual in the materials used for constructing the blocks. This one was made from nothing more than a piece of cardboard and some decorator's filler; the following one began its life as old floorboards; while the third utilizes discarded packing materials.

Prosaic ingredients indeed, but you will see what can be done with them. The lessons of collage still hold true, with the artist gaining an ever-increasing insight into the way the doing process stimulates the imagination. It is the practical, hands-on aspect of these print projects that sets them aside from traditional workshop activities and places them firmly in the realm of experiment and speculation.

Put at its most simple, a collograph block consists of a base plate — usually cardboard — with various materials glued onto it. The actual materials can be a different cocktail each time, and you can range as widely as you like to provide a rich variety of textures and shapes. You can use fabrics, dried grasses, feathers, wool, string, bubble packing, pieces of corrugated cardboard — the list is endless.

As long as you can roll over the block with an inked roller (oil paint can also be used) it will print, but take care not to build up the surface too high with sharp materials or you may tear the printing paper. As in all printmaking techniques, the paper makes its own contribution to the finished image, so experiment with different surfaces. There is no right and wrong type of paper to use; suitable surfaces range from ordinary cartridge paper to beautiful but expensive "Japon" papers, and between these extremes there is a wide choice of inexpensive surfaces.

Simple hand pressure or pressure applied with the back of a spoon will produce a good print from a collograph block, but as a "footnote" to this project I have included an example of an intaglio print from the same block printed with a press. This points up the differences between the two processes, and may be of interest to those who want to take their experiments in printmaking further.

▲ **1** The block was based on a sand dollar owned by the artist, which is shown here surrounded by some of her preliminary studies. It was important that she familiarized herself fully with the object before starting to construct the block itself.

▲ **2** The block is to be built up in layers over a cardboard base. Here the artist is mixing decorator's filler with acrylic gel medium, which gives an elastic quality well suited to modelling.

▲ **3** Building up in layers allows her to incorporate a variety of textures, and here fine gauze is being placed in position.

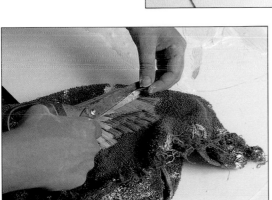

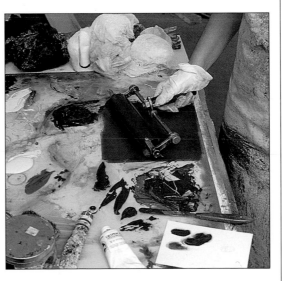

▲ **4** More or less any materials can be used to add texture as long as they do not stand too high on the surface, as this could tear the printing paper. The artist is now cutting nylon bristles from a floor brush, which adhere to the still-wet filler. Once complete, the block is coated with polyurethane varnish.

◀ **5** The colour is mixed, with care taken to achieve a hue compatible with the original subject and the artist's understanding of it. Libson is a skilled and experienced printmaker and knows how her colours will perform when printed. When using toned paper and oil-based inks, which are transparent, it is important that both colours should blend well together.

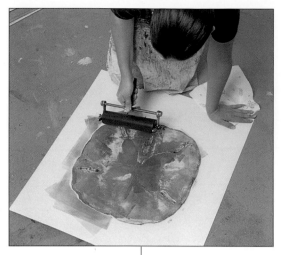

▲ **6** The colour is now rolled all over the block with a hand roller, a procedure which takes a little practice to master.

▶ **7** Unwanted colour can be easily cleaned off the block using white spirit and kitchen paper. This would not be possible without the protective layer of polyurethane which was painted not only all over the block but also on the surrounding card area.

▼ **8** The block is now ready for printing, and the artist places a sheet of Japanese block-printing paper carefully over it.

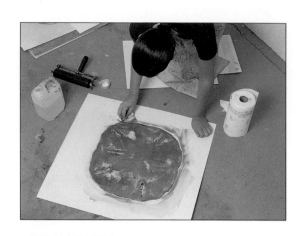

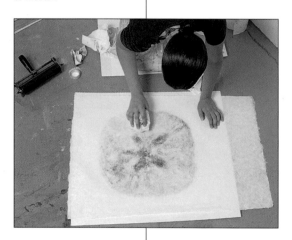

▲ **9** Each collograph block is different, and the method of applying pressure to make the print may involve some trial and error. In this case any fierce pressure would tear the paper so Libson uses a soft rag "ball" to gently rub through the back of it.

▼ **10** With one hand securing a corner of the printing paper, the artist gently lifts the print to check progress. She then replaces the paper and applies some further pressure.

▼ **11** After printing was complete, the block was inked up again to become an object in its own right – a piece of sculpture based on the sand dollar but by no means a copy of it.

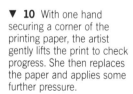

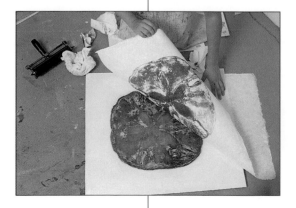

◄ **12** The relief print from the collograph block is shown below; this is a print made by the intaglio process, which gives a very different effect. In intaglio printing it is the incised lines and cut-away areas that print, while in relief printing it is only those parts that stand out in relief – hence the name. Etching and engraving are both forms of intaglio printing, which cannot be done by the hand-pressure method.

Cypher Series
Heather Libson
62.9cm (24¾in) square

PROJECT 25 | CARDBOARD PRINT

Good prints can be made without elaborate equipment, as David Ferry shows here.

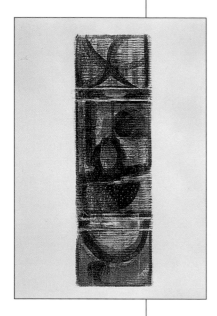

Single Box Display
66×20.3cm (26×8in)

Materials & Equipment

Cardboard box

Polyurethane varnish

Oil-based printing ink

White spirit

Craft knife, felt pen

Good quality cartridge paper

Japon-type printmaking paper

The main distinctions between the various printmaking processes lie in the physical differences between the materials used to make the blocks. The print taken from a constructed block like that shown on the preceding pages can never resemble one taken from a woodblock, which forms the next project. For the print shown here I have taken the lead from the lino-cut technique and used the same principle of cutting away the negative parts of the design. Instead of lino, however, I have used corrugated cardboard (discarded packaging), which creates a quite different effect.

Cardboard is soft, pliable and easy to tear, cut or scratch, which makes it ideal for rapid experimental work. Cutting a lino block, in contrast, is a relatively slow and deliberate process. It is not possible to take many prints from experimental cardboard blocks, as the surface destructs very quickly. They must be treated with polyurethane wood varnish before printing, which gives some rigidity and prevents particles flaking off under pressure. It also allows ink to be cleaned off without the block becoming water-logged (or "spirit-logged") if spirit-based inks are used.

In this example I prepared two blocks of identical size and printed one over the other in different colours of spirit-based ink, which I prefer because they are more transparent than water inks and give a highly professional look. The texture of the cardboard, picked up by the inked roller, gave an interesting pattern of broken lines which could not have been achieved by using any other type of block.

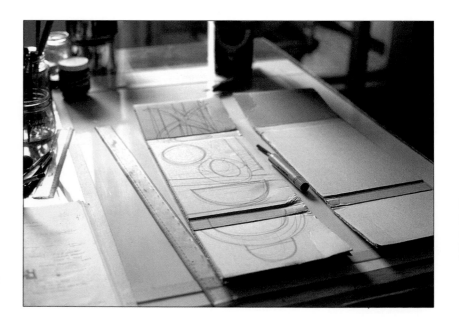

▶ **1** The pieces of cardboard – two sides of a cardboard box – were laid side by side on the studio table. With a thick felt pen I drew a design on one piece of the cardboard, leaving the other blank as it is to be used only for background colour.

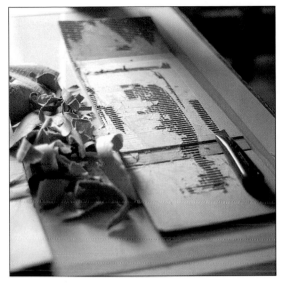

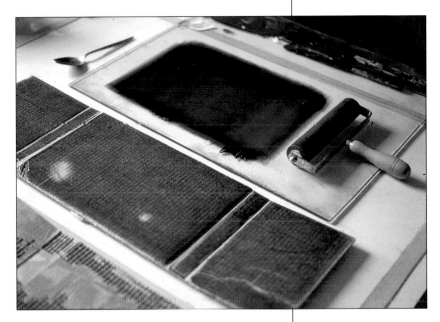

▲ **2** Because I wanted a strong texture for the background colour I then pulled off parts of the top surface layer of the second cardboard block with a craft knife to expose corrugations below. When printed, this will give a more interesting effect than a flat colour.

▶ **3** As yet the design on the first block has not been cut out. This is now inked up with green, which I shall print before going any further.

◀ **4** Placing the paper over the inked block, I rubbed it with a spoon, resulting in a slightly uneven print which is very much a feature of this non mechanical method.

▼ **5** The first block was then cleaned with white spirit, having previously been coated with polyurethane varnish. This prevents the ink soaking into it and allows me to clean the block after use without the soft carboard breaking up.

▶ **7** When one colour is printed over another some registration system is needed. In this case it is very uncomplicated because both blocks are exactly the same size. I simply place the second block on top of the first impression and then, holding the block in one hand, turn the whole block-and-paper sandwich upside down with the other. The print is again made by rubbing the paper with a spoon.

▲ **6** The second block is now inked up with red preparatory to being printed over the green. I have first rolled out the ink on a glass slab to smooth out any lumps or pieces of dry ink.

▶ **8** I am now ready to cut out the design I originally drew on the first block. The felt pen marks remain when the block is cleaned, as this ink is water-based and not soluble in white spirit (the printing ink is oil-based). The shapes are cut out with a craft knife and the block is again coated with polyurethane as I have cut away some of the original coating.

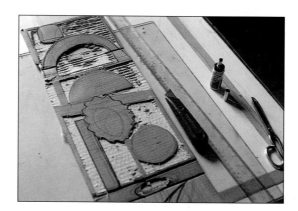

▼ **10** When the third printing had been made I decided that more cutting out and a fourth printing would be necessary, and this time I mixed a still darker tone. You can see the interesting shadow-like quality created by the two tones on the finished print opposite (right). The left-hand photograph shows the cut image printed without the background colour.

▲ **9** The cut block is to be printed over the first two colours, and is thus inked up in a darker colour. The printing procedure is exactly the same as before.

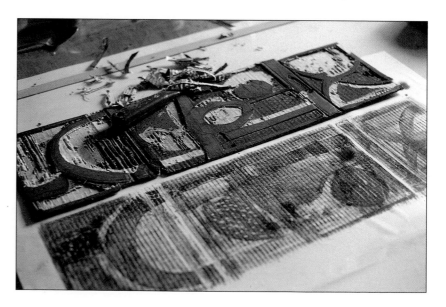

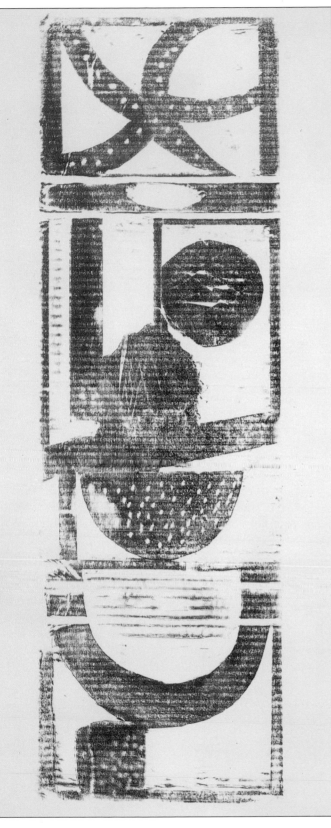

Single Box Display
David Ferry
Single-colour print
66×20.3cm (26×8in)

Single Box Display
David Ferry
Multiple-colour print
66×20.3cm (26×8in)

PROJECT 26

WOOD BLOCK

Trish Flynn's large woodblock is an ambitious project, but you can work on any scale you choose.

Untitled Hanging Piece
3.65×1.52 metres
(144×60in)

Materials & Equipment

Wooden planks

Carpenter's tools

White chalk

Brass-rubbing crayon, drawing crayon (block)

Hand roller, wooden spoon

Lino printing ink

Japon-type paper

Drafting film (Kodatrace)

Drawing ink, household brush

In the introduction to this chapter I put forward the idea that the block made for printing could become an object in its own right, and here this is very much the case. The block has been planned as a free-standing piece of relief carving to co-exist with the prints taken from it. In this way the artist has pushed her visual idea to its limits by exploring two different avenues at the same time.

There are no hard and fast rules for cutting a design into a woodblock; a variety of carpenter's or household tools can be used to cut, gouge or scratch into the surface. It is worth experimenting with different ones to discover the variations of line and tone you can achieve. Many different kinds of wood can be used also, though obviously, the very hard ones will be difficult to cut, and may also split along the grain. The texture of the wood is an important consideration. Very rough wood, or that with a distinct raised grain, can create exciting textural effects, while smooth wood, or a machine-planed block, will allow the cut and scratched marks to show up on the print, which can also be effective.

Here the artist has used several old floorboards found on a building site, and has incorporated the splits, cracks and the grain into her design. Woodblocks can be as small or as large as you want, but in this case the artist had a dual concern, for the sculpture and the print, so she began by joining three floorboards together side by side and then added more as she expanded the design. The final block consisted of six pieces bolted together.

If she had been interested only in the printing aspect, it would not have been necessary to join the pieces of wood. The various parts of the design could be carved as separate blocks and then printed one after the other on a large sheet of paper. A similarly large print could even be made from one small block simply by moving it around the paper for each printing, which brings in an element of collage.

Impressions can be taken from the block in two different ways, the first being the normal printing method of inking it up with a roller, placing a sheet of paper over it and hand printing by rubbing a spoon over the back. But you can also take rubbings from the dry block, as in a brass rubbing, using a soft pencil or crayon. Both methods have been exploited here, and the effects are completely different, as you can see. Both prints and rubbings can be taken at any stage of the block cutting, indeed it is advisable to do this as it enables you to see how the design is shaping up.

◀ **1** The artist begins by drawing a design on the wooden blocks with white chalk. Initial research in the form of sketchbooks and notebooks can be seen alongside. The blocks in this case were old floorboards bolted together with metal plates at the back.

▼ **2** Using carpenter's tools, she cuts away the areas around the design. It is the uncut areas, which in effect stand out in relief, which will make the printed (or rubbed) image.

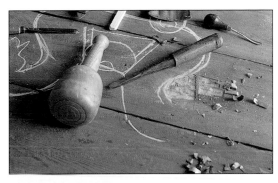

▼ **4** A hard crayon is used to produce a rubbing from the cut block. The artist is using an imitation Japon-type paper, which is a traditional block-printing paper. Although thin, it is very tough and has a lovely delicate quality. The resulting image can be seen in the next photograph.

▼ **3** This close-up of the block after cutting shows the attractive texture which makes the block a sculptural work of art in its own right.

▶ **5** The rubbing, although a complete image, only represents one fragment of the whole block. A rubbing differs from a print, but it is still essentially an impression from the block, showing qualities of both drawing and printmaking.

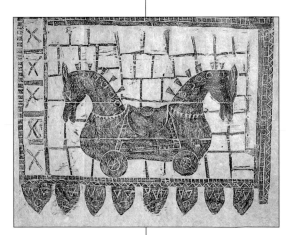

▶ **6** A large wood block can be inked up in exactly the same way as a lino or cardboard block, with a small hand roller. In this case, however, only a portion of the whole block is to be printed.

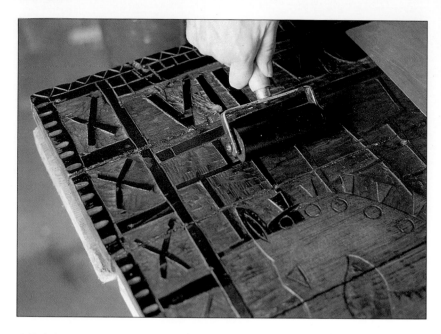

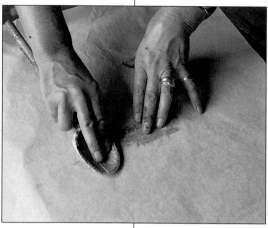

◀ **7** As in the cardboard print shown in Project 25, pressure from a spoon will produce an excellent print. The Japon paper was again used for the print, as it holds ink just as well as the crayon used for the rubbing method.

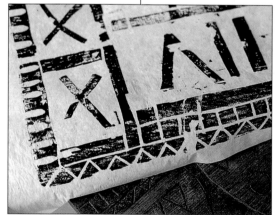

▲ **8** The texture of the paper and the print can be seen clearly in this detail. Texture is an important element in this work, and the old wood was chosen with this in mind.

▶ **9** The complete block has been photographed outside to show the scale of the carving; its measurements are 2.38×1.16 metres (94×46in). As well as providing a series of blocks for printing, the piece is also an exciting piece of sculpture somewhat reminiscent of a carved temple door.

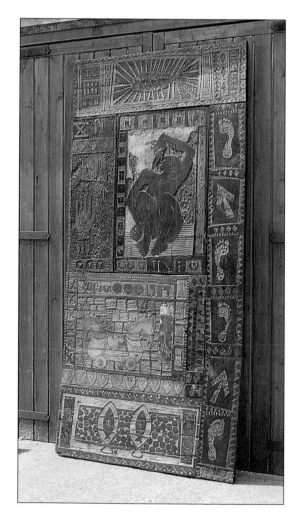

▶ **10** The final image is a full-scale rubbing made on drafting film, a plastic-coated material used by graphic artists and in the printing industry (it is usually available from silkscreen stockists). The "print" is larger than the block, and the arrangement of the individual motifs is different, as the film was moved around on the block to make a series of separate rubbings. Once these were complete the whole surface was brushed over in a transparent sepia-coloured ink, and the hanging was displayed so that the viewer was able to walk round it. This gives the physical impression of a piece of sculpture, but with an added dimension, as both sides of the rubbing can be seen at the same time (drafting film is a transparent material).

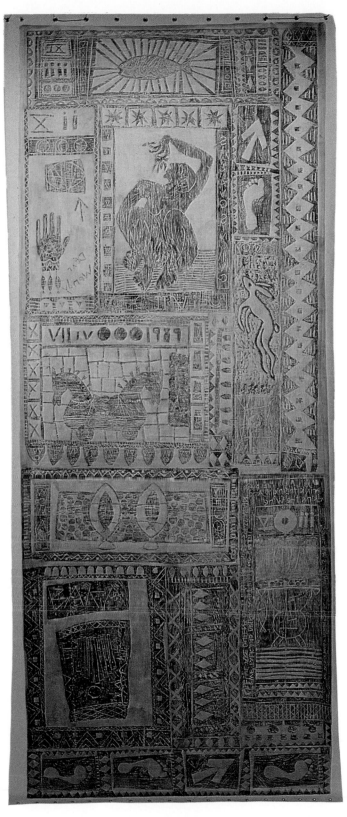

Untitled Hanging Piece
Trish Flynn
3.65×1.52 metres
(144×60in)

PRINTED COLLAGE

Nicola Rae has combined printing techniques with some of the methods used in her earlier painted collage.

Gulls, Lobster and Fish, Dieppe Harbour
50.8×45.7cm (20×18in)

This project combines printing and collage, with elements of painting also, indeed it takes off from Project 11, the painted collage, and uses some of the same techniques.

Here also the artist began with stretched canvas (cotton duck), which formed the support for the final picture. A further piece of canvas, stretched over plywood, was used for making the collage fragments, but in this case they were printed from cut lino blocks rather than being painted, as in the earlier example.

The artist has used both oil paint and lino ink for the individual prints. The image of the gull was achieved by inking up the block, placing it on the calico and then standing on it; a press was not needed. When dry this was cut out and glued into position on the stretched canvas.

In order to provide a variety of textures and effects for the finished picture, she has used several different printing techniques for each of the collage components. The "block" for the lobster was a sort of platform of thick oil paint, which was left to dry and then rolled up with lino ink, a method related to the collograph block explained in Project 24. Another variant was to press calico into an inked-up lino block with a wooden spoon. The calico was then peeled off, pressed onto another piece, and drawn into with a sharp pencil. The impression this leaves is subtly different to that of a first impression.

Materials & Equipment

Stretched canvas

Prepared calico boards

Brown vinyl tape, PVA glue

Glass slab, palette knife

Oil paint, oil-based lino inks

Lino blocks, lino-cutting tools

Hand roller, wooden spoon

Picture restorer's gold paint (as in Project 11)

Oil crayons, pencil

Craft knife, sculptor's modelling tool, scissors

Protractor and compass for sun shape (as in Project 11)

▼ **1** Each collage piece is prepared separately, using a variety of materials and techniques. These are two of the completed "fragments", all of which are images in their own right, unlike the components of a paper or photographic collage.

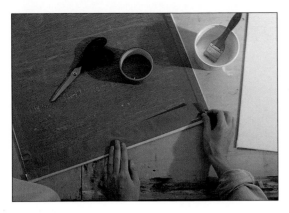

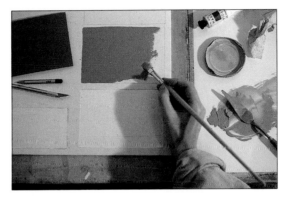

▲ **2** As in Project 11, the artist begins by preparing calico boards, which are to become the main components of the collage. The calico will eventually be cut away from the board, but they are temporarily fixed together with brown vinyl tape.

▶ **3** She now paints a "platform" of oil paint onto one of the calico boards. The painted area is the same size as the lino block seen to the left, which is to be printed on top.

▶ **4** A design of fish has been cut into the lino block, which is then inked up with lino ink. A piece of primed calico is placed on top of the block, pressed with a wooden spoon and peeled off.

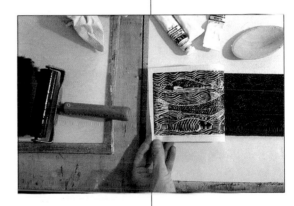

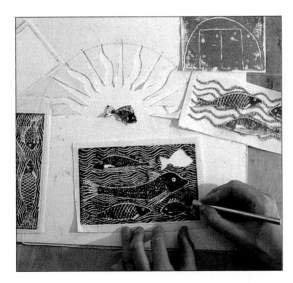

▲ **5** Once dry, the printed image on the calico is cut out with a craft knife ready to be placed on the stretched canvas which forms the base for the collage. It need not be fixed permanently at this stage, as many permutations can be tried out when all the separate components have been prepared.

▶ **6** Another lino block has now been cut and inked up. The previously prepared blue calico "platform" is placed on this and rubbed with a wooden spoon as before.

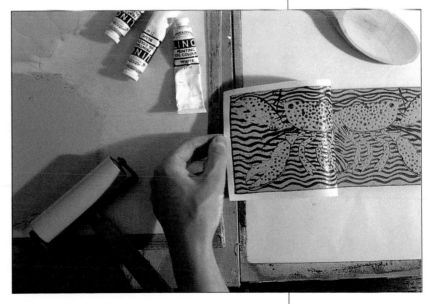

▲ **7** This photograph shows the inking-up operation, but in this case oil paint is being used instead of lino ink. This produces a slightly different, rather softer impression than lino ink when printed.

▶ **8** The printing method is also different, as the artist uses her feet to transfer the image from the block to the calico panels.

◀ **9** This collage piece was made by drawing with an oil crayon directly onto one of the calico panels. These shapes will also be cut out and glued to the stretched canvas.

▼ **10** This image was made by spreading oil colour on a glass slab with a palette knife and then drawing into it with a modelling tool. A piece of primed calico was placed over this "negative" drawing and pressed down with the hand.

▶ **11** The printed calico is now placed down onto a wet platform of oil paint, and heavier pressure is applied using the back of a wooden spoon. This yielded a very "soft focus" version of the original monoprinted image, and this became part of the finished collage.

Gulls, Lobster and Fish,
Dieppe Harbour
Nicola Rae
50.8×45.7cm (20×18in)

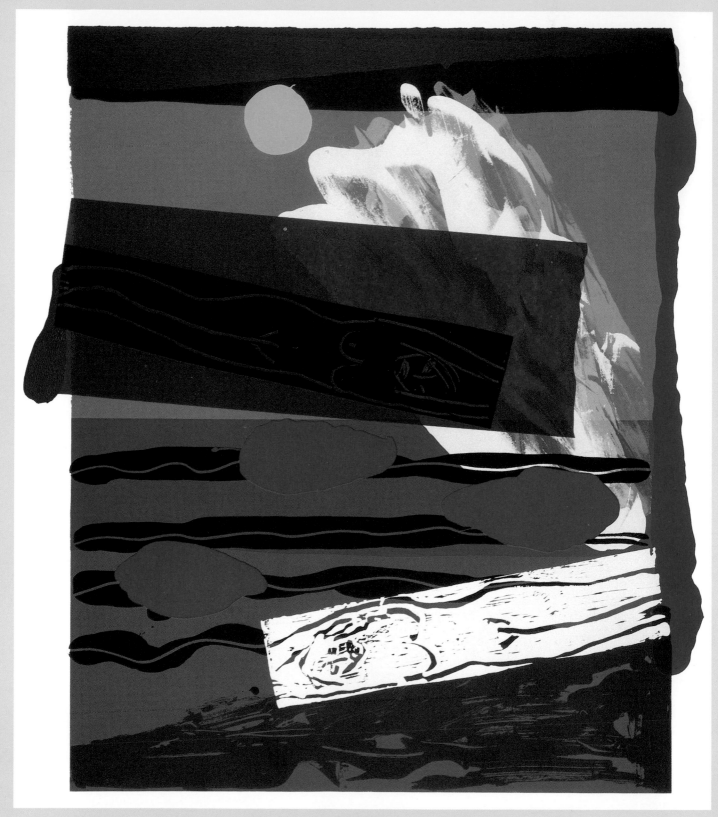

Lobster Factor Ten Days
Bruce McLean
1989

Chapter

8

STENCIL AND SILKSCREEN

Head Form
William Turnbull
1956

Silkscreen printing can be both simple and satisfying. Exciting one-off prints can be produced with little equipment.

Previous pages (left)
Screenprinting inks can be either opaque or transparent, and in McLean's simple stencil print both types have been used.

Previous pages (right)
Turnbull's print is a serigraph, that is, one made by painting or drawing directly onto the mesh of the screen.

Late Summer Balloon
Raymond Spurrier

Temporary paper masks formed the stencils for this print (below), and shapes were defined by printing one transparent colour over another.

The words "silkscreen" and "screenprinting" have a distinct aura of the technical — surely this is a complicated process that requires a great deal of equipment and is difficult to understand. But while it is true that screenprinting can be highly sophisticated, making use of all sorts of complex photographic techniques, it can also be simple, satisfying and no more difficult than the cardboard print shown in the last chapter (Project 25).

BASIC PRINCIPLES
You may also wonder why stencil and silkscreen have been paired in this chapter, but the reason is quite simple — the latter is a development of the former. Stencilling, which most of us have done at one time or another, is based on the idea of pushing ink or paint through a design cut in a piece of paper or card. It is very much like masking off one or more areas of a picture so that these remain white, the only real difference being that the stencil is not fixed to the working surface. It can be moved around to allow several versions of the design to be applied to the paper: in different colours, separate, overlapping or one on top of another.

In silkscreen printing the stencil is made on the screen itself, which has a number of advantages. The parts of the design in a cut stencil have to be joined to one another in some way. The letter A is an obvious example of a potential problem. If you were to cut this out of stencil paper the triangle formed above the crossbar and between the two sides would fall out unless a bridge was made to keep it in place. But such a stencil can very easily be made on the screen by simply sticking the "negative" parts (those which are not to print) onto the screen or painting around the letter with a masking paint or fluid. This fills up the small holes in the fabric and prevents the ink going through.

A silkscreen is nothing more than a piece of fine mesh stretched over a wooden frame, very much like a canvas on stretchers. The usual method is to make the design, or stencil, on the top side (the equivalent to the back of a stretched canvas). The printing paper is placed below, and ink is pushed over the design with a rubber-bladed implement called a squeegee, which forces it through the open mesh onto the paper. Alternatively, a design can be cut in stencil paper or acetate film and placed under the screen on top of the printing paper. And you do not even have to use the stencil principle; a print can be

made by a method known as "open screen", which is shown in Project 29.

BRIEF HISTORICAL SURVEY

Stencilling has been around since ancient times, and in the 4th century the Chinese and Japanese used the method to make images of Buddha on both cave walls and ceremonial costumes. Japanese paper stencils became more and more intricate and delicate, sometimes being printed in four or five colours, and in the 18th century the problem of bridges, mentioned earlier, was solved by a system of fixing one part of the stencil to another with very fine hairs or threads of silk.

Silkscreen was a later development, the first patent being granted to Samuel Simon of Manchester, England, in 1907. His system was based on a stopping-out liquid painted directly onto the screen, with a bristle brush used to force the ink through the mesh. By 1914 an American John Pilsworth, had developed a system of printing in several colours from one screen, and this was eagerly taken up by manufacturers. During the First World War his method, called Selectasine, was widely used for flags, banners and bunting.

There were many improvements made to the silkscreen process, and its commercial applications spread to almost every area, from display signs to the decorating of pottery. Artists only began to exploit it in about the 1930s, but have done so consistently ever since. Its ability to produce large, bold areas of colour, powerful images and subtle textures ensure its continuing appeal, and provided the screens are not too large and you restrict yourself to one-off prints rather than huge editions, it is perfectly possible to produce screen prints at home.

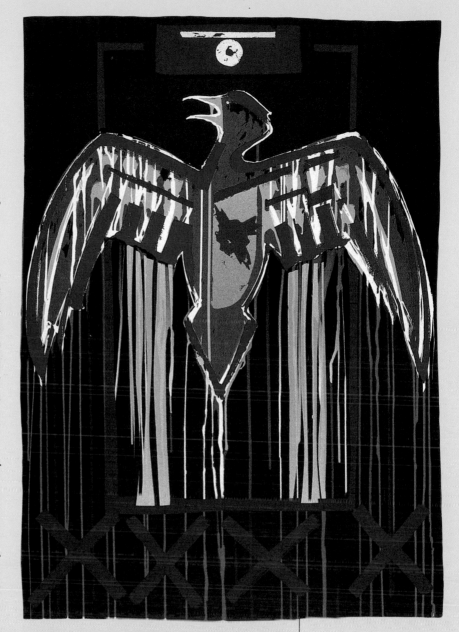

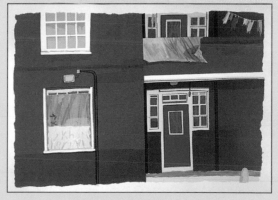

The Second Bird
Anita Ford 1989

Cut and torn paper stencils were used for the larger shapes (above), and the linear elements and textures were made by painting on the mesh with blue filler (see Project 29).

Shadwell Flats
Janet Brooke 1990

Brooke's print (left) was produced by a combination of cut paper stencils and the open-screen technique (see project 29).

131

THE SILKSCREEN PRINTING UNIT

The projects on the following pages provide some ideas on different approaches to silkscreen printing, but those who know little about the method, or have tried it and would like to make their own screen, may find these pages helpful.

The basic screenprinting unit consists of an open frame with a fabric mesh stretched tightly over it, a flat baseboard, and a hinging system joining the two. A flexible rubber or synthetic squeegee is used to force the printing ink through the clear areas of the mesh and onto the paper on the baseboard.

Frames can be made from wood or light metal, but the latter are not practicable for home construction. A wooden frame is not difficult to make, but requires some basic carpentry skills. An advantage of the homemade frame is that you can choose the size you require – about 40.5×61cm (16×24in) is a good size to start with. The wood should have straight grain and not be warped – cedar is often used by commercial manufacturers as it is water-resistant, rigid and light to handle. Make sure the weight of the wood is appropriate for the size of screen being made, as the fabric exerts a considerable tension when stretched. However, the frame should not be too heavy to handle easily. The corners take the strain of the tension and should be properly glued and jointed as shown in the illustration, not simply screwed or nailed. Finally, all wooden frames should be coated with a protective finish that is ink- and water-repellent, such as polyurethane varnish.

THE BASEBOARD

The frame can be hinged to a table or baseboard which should have a smooth, flat surface. Formica is ideal, or board treated with coats of shellac and then sanded and sealed. The baseboard should be 5cm (2in) to 9cm (6in) larger than the frame on all sides. The frame needs to be attached to the baseboard, but in such a way as to allow the gap between the bottom of the frame and baseboard to be adjusted, thus allowing for printing paper of

It is crucial that frames should be strong and absolutely rigid, and the corners must be fixed at exact right angles. To achieve this you will need to use one of the four types of joint illustrated here. They are: (1) the end-lap joint, (2) the rabbet joint, (3) the mitre joint, and (4) the butt joint.

The most suitable hinges with which to joint the frame to the baseboard are those shown here (top and inset). The central pin can be removed to detach the frame for cleaning. Screw the hinges down tightly, making sure they are exactly aligned. The hingebar (above) should be a minimum of 5cm (2in) wider than the frame on each side. If fixed to the baseboard with a coach bolt and wingnut it can be raised if necessary.

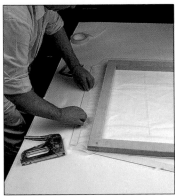

To stretch the mesh you will need, in addition to the screen itself and the mesh cut to size, a stapler, masking tape and strips of cardboard cut to the same length as the sides of the screen. Cut the mesh to size, allowing a 2.5cm (1in) overlap on each side of the screen. Lay the screen on top of the mesh on a clean surface, making sure

that the weave runs straight. Secure the strips of card to the edges with the tape and then cut the corners of the mesh. Fold the card over so that it is sandwiched between two layers of mesh (left). Starting from the middle of one of the long sides, staple along the frame (middle), ensuring that the fabric is stretched from the centre staple. Turn

the frame the other way up and staple the other side (right), pulling it as taut as you can. Finally, fold the corner neatly and staple securely.

SUPPLIERS

American Screen Process Equipment Company, 1439 West Hubbard Street, Chicago 22, Ill. (Presses and general screen printing supplies)

Apex Roller Company, 1541 North 16th Street, St Louis, Missouri 63106 (Rollers)

Becker Sign Supply Company, 319-321 North Paca Street, Baltimore 1, Md.

Graphic Chemical & Ink Company, 728 North Yale Avenue, Villa Park, Ill. 60181 (Ink and presses)

Interchemical Printing Ink Corporation, 67 West 44 Street, New York, NY (Printing inks)

Japan Paper Company, 7 Laight Street, New York, NY 10013 (Paper)

W. M. Korn, Inc., 260 West Street, New York, NY 10013 (Lithographic and silk screen crayons, general lithographic supplies)

McLogan's Screen Process Supply House, 1324 South Hope Street, Los Angeles 15, Calif.

Roberts & Porter Inc., 4140 West Victoria Avenue, Chicago, Ill. 60646 (Ink, rollers, blankets, general supplies)

different thicknesses. The best way to manage this is to fix a hingebar, made from the same size wood as the frame, to the baseboard (see photographs).

THE MESH

The mesh must be stretched very tightly over the base of the screen frame; it is this which acts as a sieve and container for the printing ink. It must be strong, durable and tensile. Usual mesh fabrics include silk, nylon, terylene and polyester. Those most often used for screenprinting are the so-called monofilament nylon and polyester, which are classified by the number of threads per square inch. The choice depends upon the type of image to be printed and the kind of ink being used. In general, for large flat areas of colour a coarse/medium grading is required, in which the percentage of open areas in the mesh is large compared to the number of threads, so allowing a greater amount of ink to pass through. A finer fabric, which will print a very thin deposit of ink, is better for detailed stencils and any linear work.

The squeegee, the implement used to pull the ink across the screen, is made of either rubber or polyurethane and comes in different grades, hard, medium and soft. For hand printing the soft blade is normally used (the one at the bottom in the photograph).

PROJECT 28

PAPER STENCIL

Mavernie Cunningham-Fuller demonstrates the exciting effects that can be achieved with simple paper stencils.

The Bird
35.6×50.8cm (14×20in)

This project demonstrates the exciting effects that can be achieved by silkscreen printing with nothing more elaborate than a stencil made of paper – the most basic method of all. All that is needed is a table or floor area, the screen, a squeegee, inks – either spirit or water-based – and sheets of paper.

Stencilling can also, of course, be done without a screen, simply by cutting a design in a piece of stencil paper or acetate film and dabbing paint onto paper through the open areas. A stencil brush or sponge can be used for this method, producing a broken-colour effect that can be well suited to some subjects. In this case, however, the artist wanted the clear solid areas of colour that can only be produced via a screen.

She began by drawing a design on thin paper, and this was then torn, not cut, as she wanted the specific character of the torn edge. The stencil was then placed on a separate sheet of paper already marked out with the dimensions of the screen frame and printing paper.

Before printing can take place, an area around the edges of the screen has to be taped at the bottom and top to prevent surplus ink from spilling or bleeding onto the printing paper. This also makes a reservoir for the ink poured into the screen, and facilitates cleaning when a change of colour is required. Brown vinyl parcel tape is ideal for this purpose. Cardboard pads also need to be fixed to the bottom of the screen to prevent it from coming down too hard on the printing paper. There has to be a slight "lift off" between the two or the ink will not be able to pass through the screen.

Once these preliminaries were completed the first colour was mixed and a print was taken. There were four printings in all, each with a separate colour and stencil. Screen inks dry very quickly, and it is possible to print quite a few overlays or changes of colour in any working session.

Materials & Equipment

Silkscreen, squeegee

Brown parcel tape

Oil-based silkscreen ink

Palette knife

Waxed paper cups

Screenwash, thinners, rags

Pencil

Thin cartridge paper (for stencils)

Good-quality cartridge paper (for prints)

► **1** When the stencil has been prepared the ink will be pushed through the mesh with the rubber squeegee seen in front.

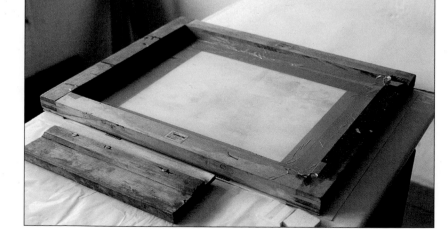

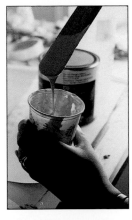

► **2** The artist is using oil-based printing ink, and here is mixing it in a wax paper cup with thinning solution. The consistency is important; it should be about the thickness of double cream. If too thick it will not pass through the mesh.

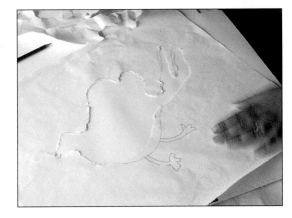

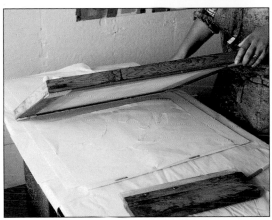

◄ **3** The first stencil was made by tearing out the shape, with a simple line drawing acting as a guide. This is then placed on the printing paper (good-quality cartridge) on the area where the image is to appear.

◄ **4** Before bringing the screen down on the printing paper the artist marked the edges of both paper and stencil as well as the exact position of the screen on the table. This acts as a simple registration system, which is important when more than one colour is to be used on the same print.

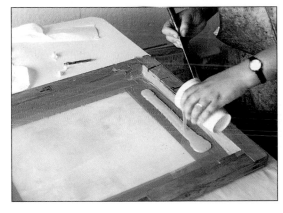

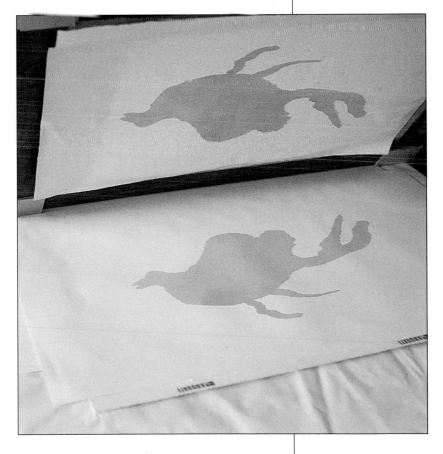

▲ **5** The pre-mixed ink is poured into the bottom edge of the screen frame. The brown tape along the edge and side provides a reservoir to hold the ink and also prevent it from going through the edges of the screen. The squeegee will now drag the ink to the top edge of screen, thus producing the first colour image.

► **6** Printing ink is sticky, so in the process of printing the stencil adheres to the bottom of the screen, enabling further pulls to be made if the first is unsatisfactory. The "lift off" pads, which can be seen on the bottom corners of the screen frame, produce a slight gap between the bottom of the screen and the printing paper. This allows the ink to pass through freely.

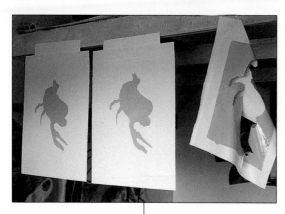

▲ **7** The first colour prints and the stencil are hung up to dry in the studio; the artist may re-use this stencil for another print or for a collage. Screen inks dry very quickly, and these prints will be ready for the second printing stage as soon as the screen has been cleaned.

▶ **8** A new stencil has now been made for the second colour, to be printed over the original yellow bird shape. Separate screens are sometimes used for each colour, but this is not essential provided the screen is thoroughly cleaned between colours. For oil-based inks, Screenwash solution is the most satisfactory.

◀ **9** The small areas of darker colour add definition to the bird shape. Notice that the registration system has kept the new colour within the boundaries of the original yellow.

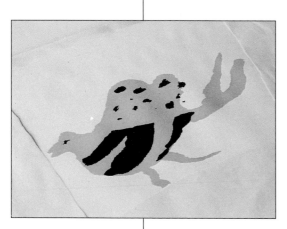

▶ **10** The third stencil is quite different from the ones shown earlier, consisting of no more than small paper shapes spread fairly randomly over the printing paper. The effect of these can be seen in the finished print opposite.

▶ **11** Again the ink is poured onto the bottom edge of the frame. This is the third colour, and a fourth, red, was added afterwards. As can be seen from the final picture opposite, a fifth colour, green, has been produced by printing blue over the yellow. Oil-based inks are transparent, so overprinting will always produce mixtures of this kind.

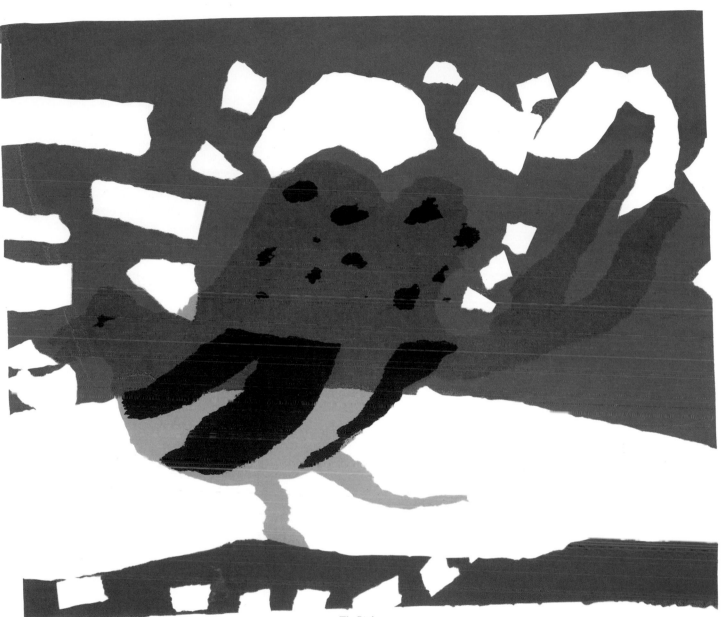

The Bird
Mavernie Cunningham-
Fuller
35.6×50.8cm (14×20in)

PROJECT 29

OPEN-SCREEN PRINT

Silkscreen printing is a versatile process, and Janet Brooke shows an alternative approach.

The Gas Works Again, No. 1

63.5×83.8cm (25×33in)

These two prints (left and opposite page) show an equally simple but quite different use of the silkscreen. In the previous project stencils were used to inhibit the ink so that the parts of the screen left clear were those that made the image. This makes what is in effect a "negative" print, but it is also possible to make a "positive" one by drawing on the screen and pushing the drawn lines themselves through the mesh

In this case the artist has used oil pastels for the drawing, but instead of pulling ink over the screen with a squeegee he has used transparent extender. This is a product specially made to give extra transparency to screen inks, and the effect it has on oil pastels is to break down and semi-melt

them so that they pass through the mesh quite easily.

Open screen has parallels with monoprinting and is a similarly swift and direct way of making prints. Although made via a screen they are not strictly speaking screenprints, as the results are necessarily one-offs. They are sometimes called serigraphs.

There is another way of making this kind of positive print, which uses some of the techniques of lithography. It involves drawing with greasy (lithographic) crayon, then covering the whole screen with gum arabic and finally washing off the drawing with turps, to leave the mesh open wherever the crayon has touched. Very subtle effects can be achieved in this way, but it is more laborious than the method shown here, and a great deal more messy, so is not recommended for home experiment.

Materials & Equipment

Silkscreen, squeegee

Oil-based screen inks

Oil pastels

Rags, palette knives, cardboard scrapers

Silkscreen extender base

Silkscreen thinners

Screenwash

Good-quality cartridge paper

▶ **1** These oil pastel studies were done before the artist began work on the screen prints. They were made directly from the subject, and this quality of first-hand observation is also evident in the final prints. The choice of oil pastels was deliberate, as these were also used to draw onto the screen mesh.

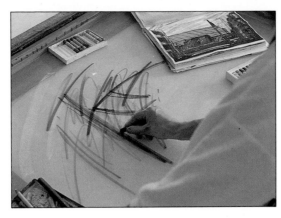

▶ **2** The artist draws directly onto the mesh of the screen, referring to her sketch as she works. The printing paper has already been placed under the screen.

▶ **3** Extender base is now poured along the top edge of the screen. The squeegee will drag the extender over the oil pastel and melt the colour sufficiently to allow it to pass through the mesh onto the printing paper. The print is illustrated opposite.

▶ **4** The second print was made in an equally direct way, by simply painting screen inks onto the mesh. This technique is really a synthesis of printing and painting. Palette knives, cardboard squares and brushes can be used to develop an image on the screen.

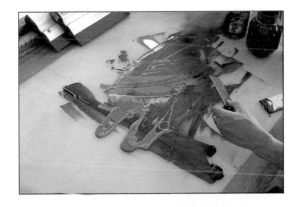

The Gas Works Again, No. 2
Janet Brooke
63.5×83.8cm (25×33in)

▼ **5** When the painting is complete the squeegee is pulled down over it in the usual way. The open gesture of the print (right) fully exploits the rich atmosphere of the subject matter. This print is a particularly good example of an expressive and confident drawing activity bonded with a printmaking process.

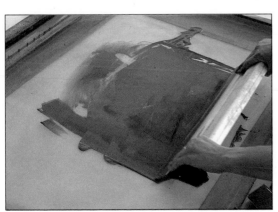

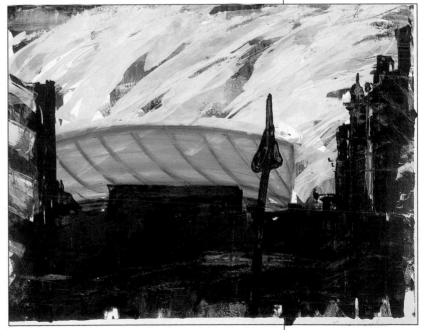

PROJECT
30

PAINTING ON THE SCREEN

Here Janet Brooke has combined a painted stencil with cut paper shapes, and also worked on the print itself.

No Poll Tax Here, No. 1
63.5×83.8cm (25×33in)

Like the previous example, this has a highly professional appearance but was actually produced quite simply. It is important for the novice screenprinter to realize that the word "stencil" has a very wide application. It does not just refer to a simple shape cut out of paper but to anything pasted or painted onto the screen which inhibits the passage of ink through it, so a silkscreen stencil can take the form of big, bold shapes, fine lines, spattered and splashed paint, dots, squiggles or whatever you choose – you have the whole repertoire of painting and drawing at your disposal.

One of the materials made for preparing silkscreen stencils is a substance called blue filler, a water-soluble liquid which nevertheless dries hard. This can be painted onto the mesh with any number of different implements, such as sponges, rags, fingers, or pieces of cut card. It can also be spattered or sprayed on with a toothbrush or old bristle painting brush.

All these areas will appear white on the print, as the filler does what its name implies and fills the holes in the mesh so that no ink can go through. A substitute is gum arabic, which can be bought in most art shops, but because it is transparent you may need to put a little poster colour in it so that you see the marks you are making.

For this picture the artist used a combination of the painting method, cut and torn paper stencils and the "positive" oil pastel technique shown in Project 23. But this was by no means the end of the story; the printed image was then manipulated further by working directly onto the paper itself.

Such procedures would probably seem heretical to the purist or professional silkscreen printer, who sees the process as a means of producing a large edition of identical prints. This book, however, is about breaking away from traditional techniques, and in this context the real "process" is self-expression.

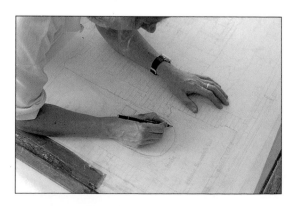

▲ **1** Having drawn the design for the print on a sheet of drafting paper, the artist places this under the mesh of the screen. The drawing is clearly visible, enabling her to establish the main compositional elements on the screen itself by drawing on the mesh.

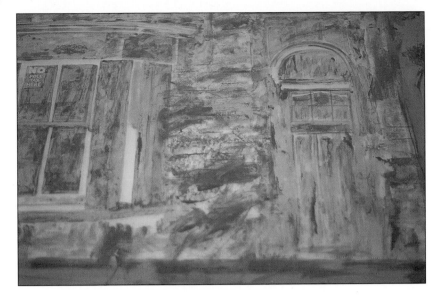

◄ **2** She then applies the blue filler, which will inhibit the passage of the screen ink. A number of different painting methods have been used for this, including scraping the filler on with a piece of card, painting with a brush and dabbing with a sponge. The accuracy of the initial drawing allows the filler to be applied very freely.

▼ **3** A number of these painted stencils was made, and cut and torn paper stencils were also used. The latter are responsible for the clear-edged white areas on this early print. Here the underlying colour is clearly visible, although in the final versions it may be only just evident.

► **4** Because the inks are transparent, subtle tints and build-ups of colour can be achieved by successive overprintings, as seen in the finished print opposite. Here the artist is taking another print from the same edition and working on it further to produce a different interpretation of the subject. She has painted Screenwash (the ink cleaning agent) onto the surface of a print and is blotting it with thin newsprint to achieve the effect seen in the final photograph.

No Poll Tax Here, No. 2
Janet Brooke
63.5×83.8cm (25×33in)

One of the beauties of the silkscreen process is that it can produce a number of identical prints which can become a basis for further experiment. You may want to retain one as a "straight" print, as the artist has done here (see opposite), but many lessons can be learned from going one creative step further, and prints can be worked on in more or less endless ways to become true "one-off" expressions.

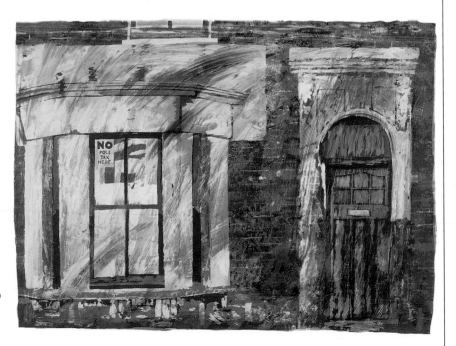

INDEX

Page numbers in *italic* refer to the illustrations and captions.

CREDITS

Quarto Publishing would like to thank the following galleries, museums and institutions for supplying photographic material and giving permission to reproduce works in their collections:

p.6 Tate Gallery, London; **p.7** V & A, London/Bob Tegg; **p.9** Marlborough Fine Art, London; **p.10** Kunsthalle Nurnberg, Germany; **p.11** Tradhart Ltd, Berkshire; **p.12** British Museum, London; **p.13** Arts Council of Great Britain, London; **p.14 (below left)** British Council London; **p.15** Marlborough Fine Art, London; **p.30** Museum of London; **p.31** British Museum, London; **p.33 (above)** Tate Gallery, London; **p.50** Tradhart Ltd, Berkshire; **p.52** Musée Beaux-Arts Du Canada, Ottawa; **p.53** Lee Miller Archive, East Sussex; **p.82** Museum of Modern Art, New York; **p.94** Scottish Gallery, London; **p.108** British Museum, London; **p.109** British Museum, London; **p.111** Austin Desmond Gallery, London.

Quarto would like to thank all the artists who have devoted their time to this book and in many cases have kindly supplied their own photographs.

Every effort has been made to trace and acknowledge all copyright holders. Quarto would like to apologize if any omissions have been made.